豐 和 日 麗

A Beautiful Day III: Internal Dialogues

攝影
詩集

告白的力量

田 定豐

獻給　勇敢的自己
A heart of steel starts to grow.

目次
CONTENTS

自序
Preface

彷彿從揹起相機的那一刻起，就註定了「豐和日麗」一路的使命。
從夢想談到了愛情，從愛情談到了人生。
然後，發現每一張照片，每一段文字，其實不只是療癒別人，更是對自己
最誠實的告白。
我也在這告白之中，更了解自己生命的輪廓，和在這輪廓最深處的地方，
看見了自己的軟弱與堅強。
原來，生命大多時候，我們都只是選擇我們想看見的風景，而去避開心裡
最闇黑的角落，以為從此身心就能相安。
但我卻常在生命裡來去的人身上，按下了自己生命陰影的快門，然後反覆
咀嚼這份對自己的陌生。也漸漸的才明白了人生，而「歲月」則成了代價。
假如這些領悟，可以成為不只是紙上的匆匆一瞥，而是成長生命的甘露。
那麼，我們之間的告白，將會是能繼續前進最有力量的勇氣。

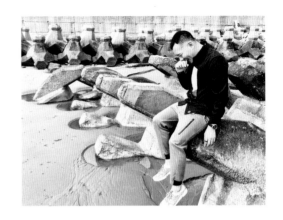

田定豐
Lancaster Tien

From the moment I took up my camera, this series of photo-slash-poetry books
became an eventual outcome. It serves as the keeper of my thoughts, extending from
dreams to love, and from love to life. It's only then I realized that my photographs
and poems do far more than tending to the vulnerable hearts of others; they are also
my internal dialogues.
Through these naked self-talks, I gained a better perspective of my own life, and saw
my own vulnerabilities and strengths within its depths.
I came to an understanding that, more often than not, we see only what we choose to
see; both consciously and unconsciously, we avoid facing the skeletons in our closets,
exercising "out of sight, out of mind" to a fault. Yet, ironically, I frequently take
snapshots of my own deliberate negligence in the life of others, and then sleep on
the eerie unfamiliarity with myself in which they reflected. From them, I learned life's
valuable lessons, at the cost of irretrievable time.
My only wish is for these life lessons of mine to be more than mindless scribbles to
others, but something that nurtures and nourishes life. If that comes to pass, these
intimate conversations between us and ourselves may very well be the greatest
strength and ally on our life's journeys.

幸福是自己給自己的
Be Your Own Angel

愛，不只是歲月裡流動的風景；
而是彼此願意以匍匐前進的理解，
成為相融的靈魂。

Love is more than icing on the cake that is life.
It is a mutual understanding and commitment,
In sickness and in health, for better and for worse,
To become wedded souls.

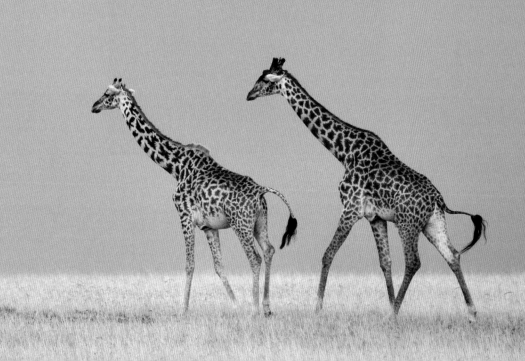

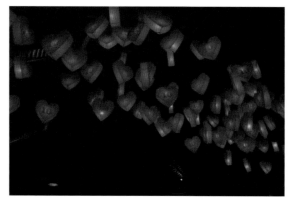

真正有愛的人，是不會因為被人傷害過，
就從此對人性失去了信任！
因為，愛會帶著無限的勇氣茁壯你的人生，
它從來都不帶著條件或者期待，當然也就不會受傷。

A loving soul never loses trust and faith
Licking old wounds.
Because true love gives and inspires
Without conditions or expected returns.

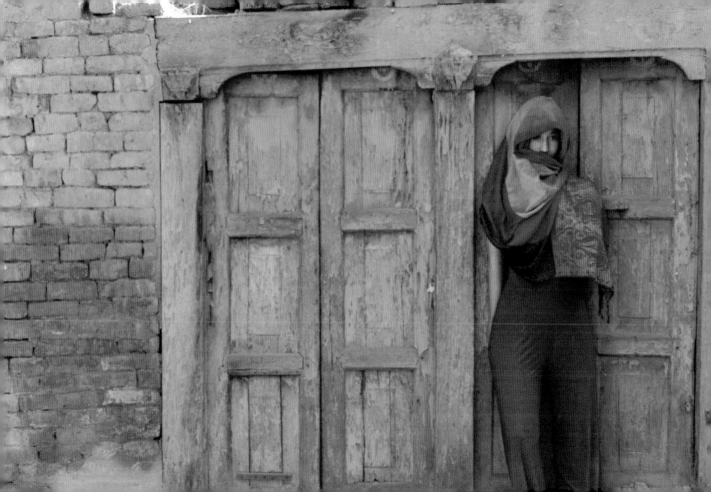

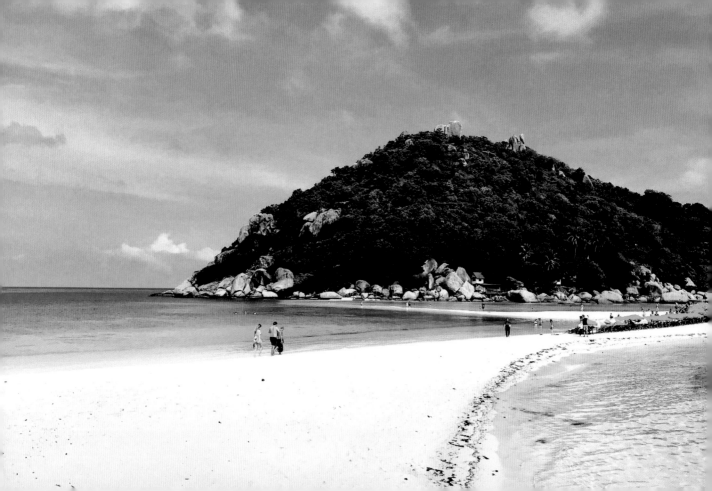

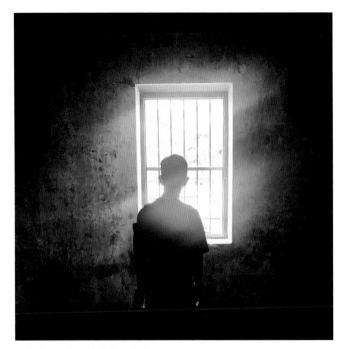

恨會傷人，但愛有時也會更傷人。
當你只想用自己以為是愛的方法，去對待一個人，
卻從不管對方是否接受的時候，這樣的愛是會讓彼此都受傷的。

Love can sting far worse than hate can bite.
For love is not love when loved the wrong way
Without any respect for the other party.

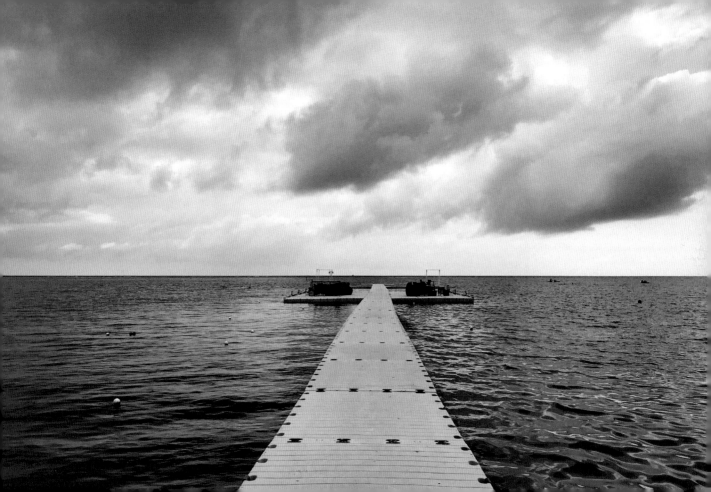

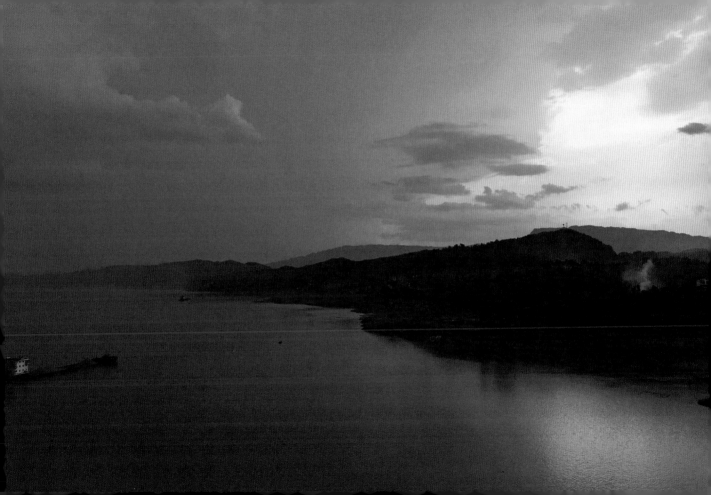

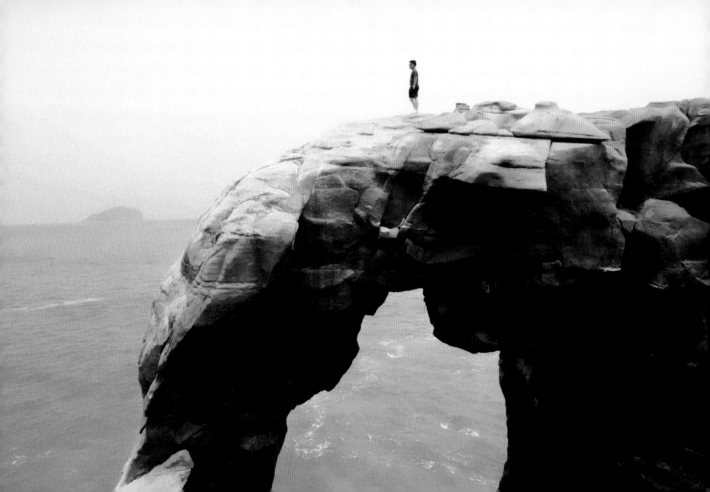

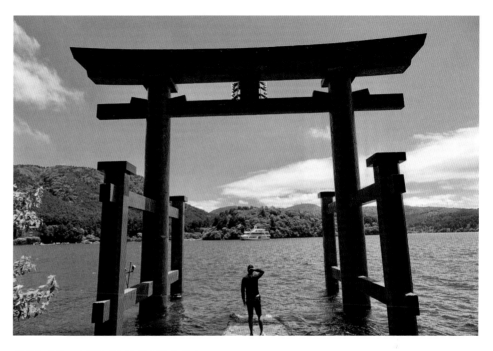

我們有時候，會想起曾經喜歡過的某個人。
其實不是因為他特別好，而是因為我們沒得到。
人常常為沒得到過的而嘆息，卻忘了最好的一直就在身邊。

Our thoughts often linger over past lovers that could never be.
Not for their merits, really, but for "could never be," precisely.
O, the farsightedness that blinds us from seeing what we hold.

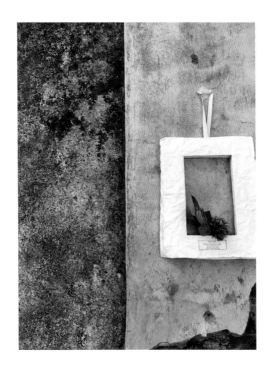

所有人的生命，都如同白駒過隙。
當你想到要抓住什麼，它都已經成為過去式了。

Life is but a blink of an eye.
You reach out to seize something——
Already, it withers in memory.

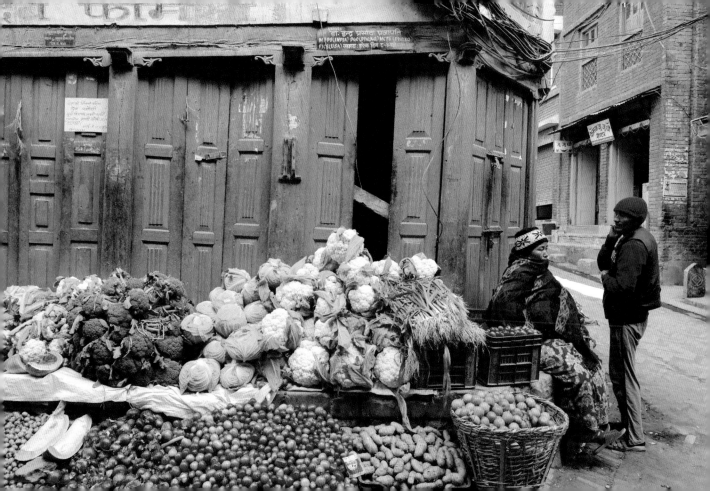

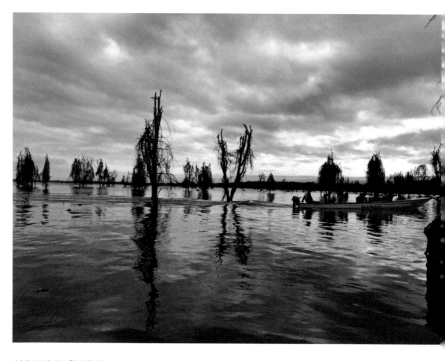

別為逝去的愛情悲傷。
我們都在每一次分合的錯誤中，更了解愛情的本質，
也才會更靠近了「幸福」。

Shed not a tear for relationships past and gone.
We grow and mature to be more capable of loving
With each passing.

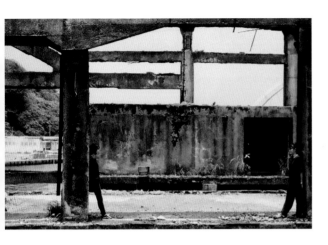

兩個人在一起，不會都是快樂的。
一開始喜歡的兩個人，在相處上一定都會有不同問題
的摩擦，我們會隨著時間經歷情感裡的酸甜苦辣。
最終能留下來的，是因為彼此都包容了彼此，即使背
對背也會是同一顆心，這才算是愛。

Being in a relationship is not all sunshine and rainbows.
Each day is a trying period, of ironing out issues old and new -
The spices of life.
Lasting love rests on balance and tolerance, for
We are two sides of the same coin.

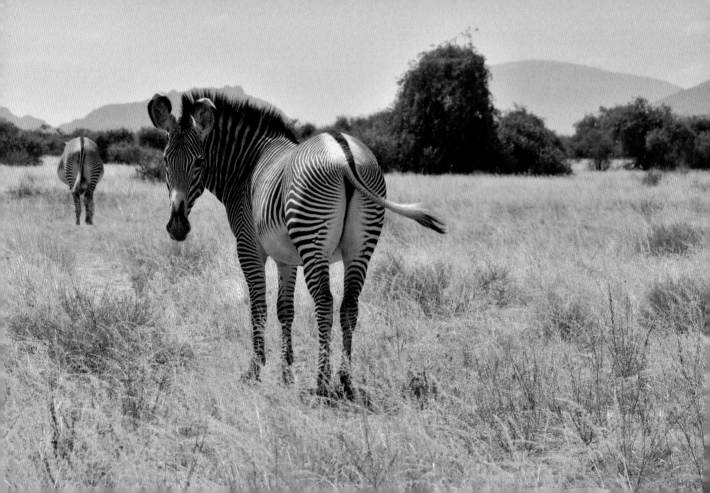

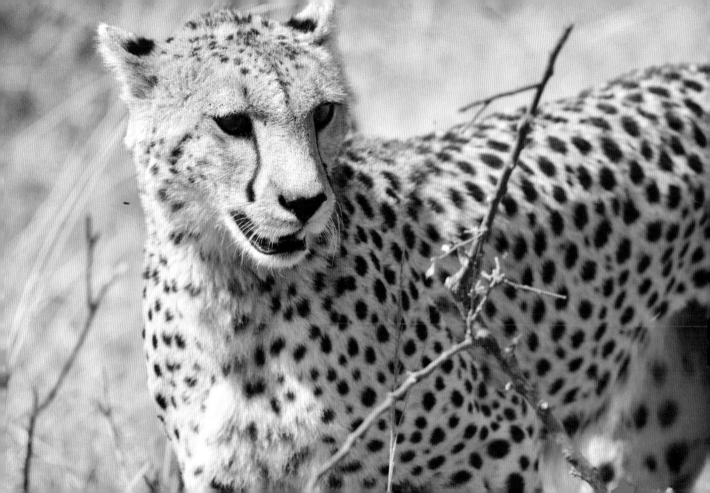

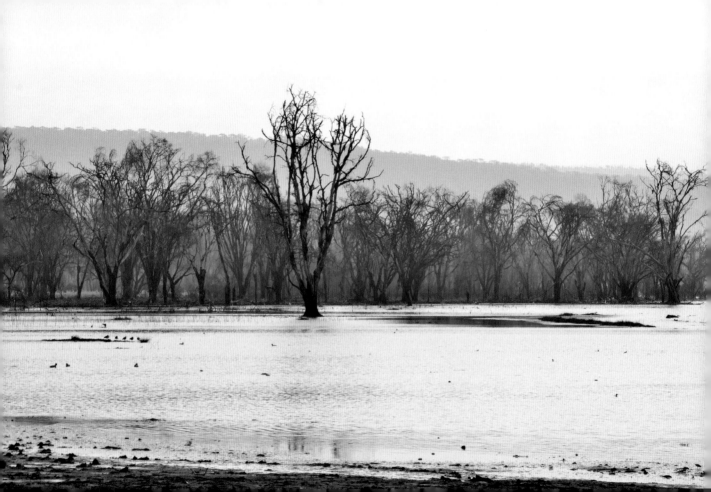

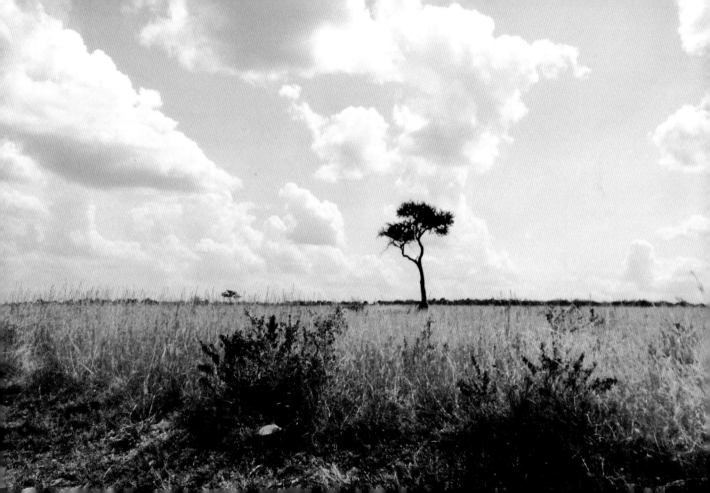

愛不是非要震懾人心的一場追求。
能有著心安尋常的陪伴，就已是幸福的答案。

Love needs not be a Shakespearean melodrama.
Comradery, reliance, solace -
The Three Wise Kings.

「殘缺」，不是辜負別人愛你的藉口。
我們當然都不夠好，但也因為這個理由，
才更需要用愛來圓滿彼此的失去，完整我們的人生。

Lacking, is never an excuse, For none of us is ever perfect.
Thus, true love is complementary To fill and fulfill.

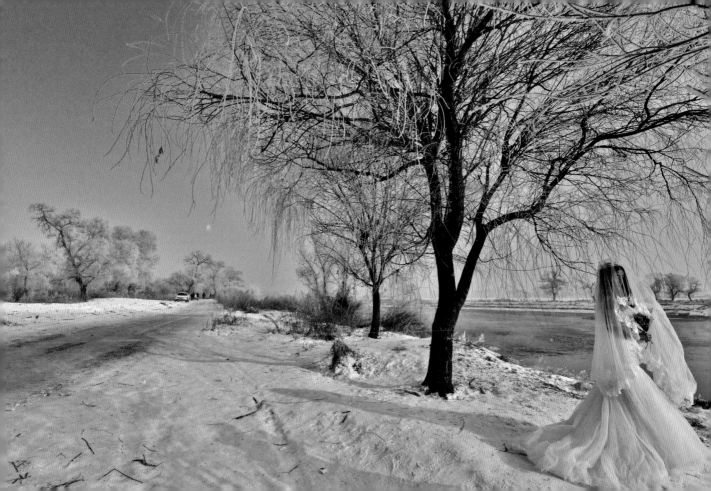

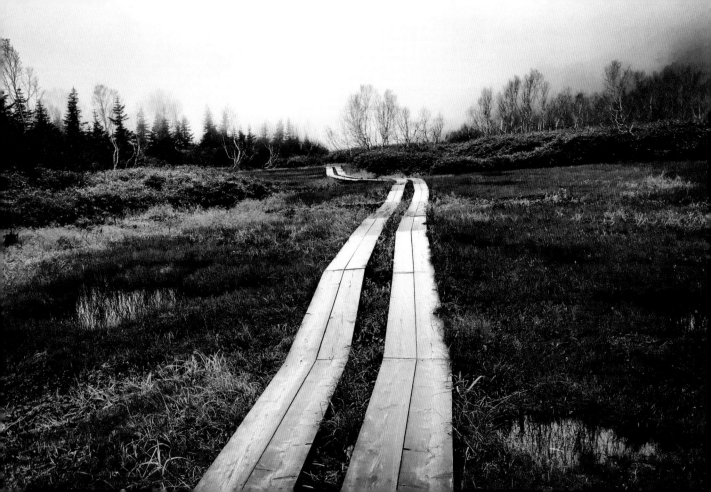

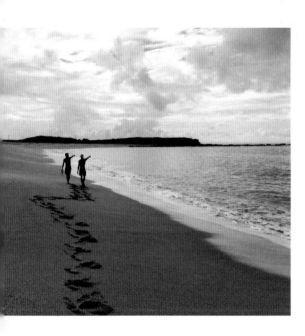

他能給的，與你想的方式不同，不是因為他不愛你。
愛是要用心來感覺對方的心；而不是只用自己的感受，
來等待對方填滿。除非你願意改變，否則你只是一次又
一次在失望中輪迴。

When the love given differs from what you desired,
Be empathetic, not egoistic.
Either get out of your own head,
Or plunge back into the same vicious cycle.

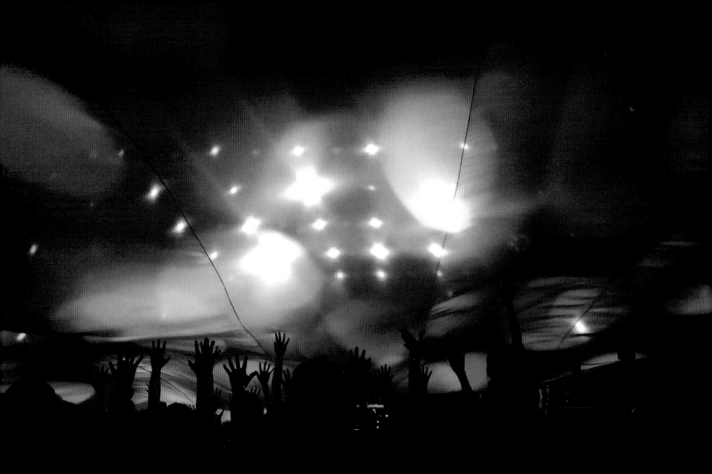

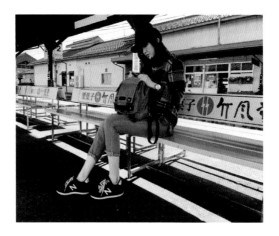

適不適合不是一種藉口。真相是，我們都忘記一開始，
在彼此心中那個最好的樣子。

When you feel "it's not working out between us"
You've just forgotten that beautiful person
You fell in love with in the first place.

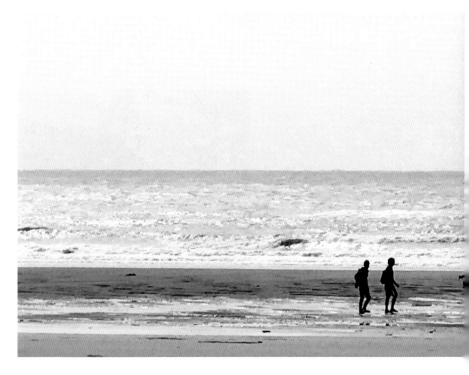

在真正的愛裡，應該是沒有任何條件的差異比較。
而是我們有能力，互補不完美的生命過程裡，完整了彼此的人生。

Love is not a competition.
It is the capability of giving
That makes each other whole in life.

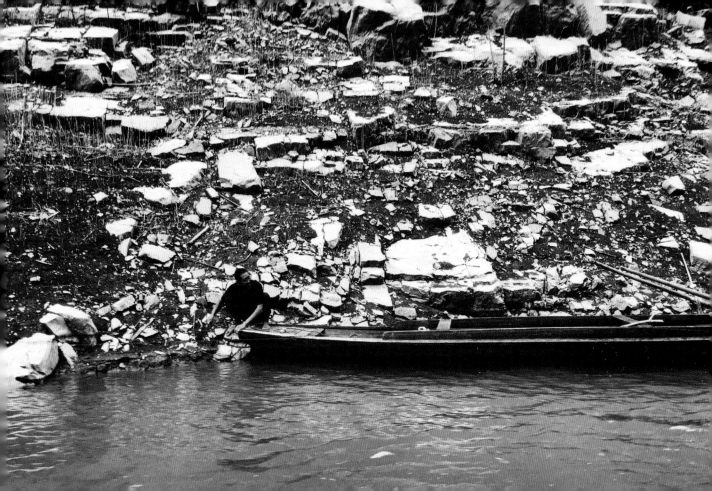

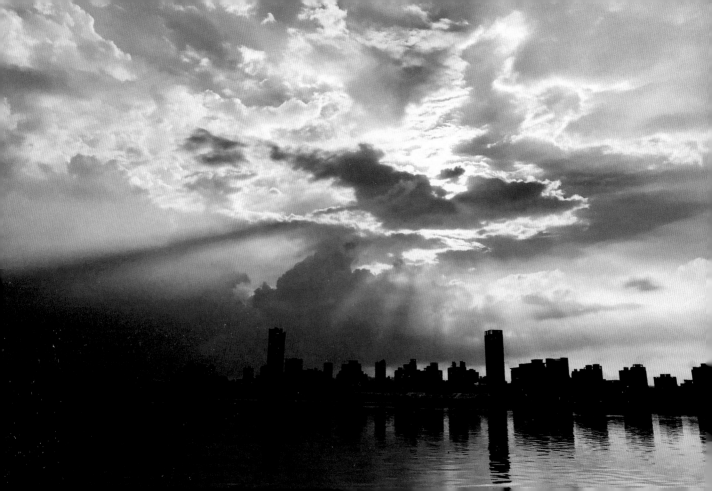

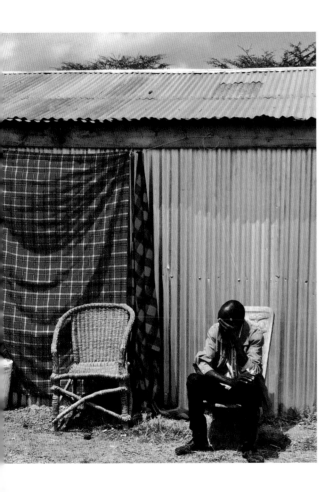

我們總是矛盾的心裡想著，能陪伴彼此到老的畫面多好；
卻又總在相處的時候，容不下對方的缺點。
直到一方離去時，才領悟了旁邊那張「空」了座位的痛。

We often beg for forever-and-ever, yet we tolerate
Not of a single spot of an otherwise spotless mind.
We revel in weeding out the undeserving
Until forlornness overtakes us.

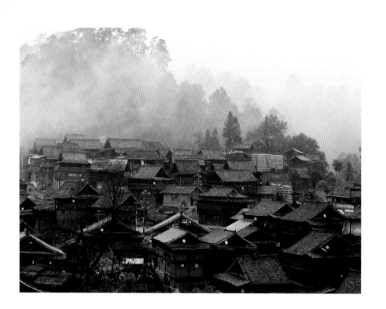

愛情不能只是隔岸觀看童話一般的想像，
你要在現實生命中經歷，
所有的美好和痛苦。
才會真正知道自己在愛裡的樣子。

Love is no fairytale of princes and princesses.
You only truly learn your role
After sailing its turbulent waters.

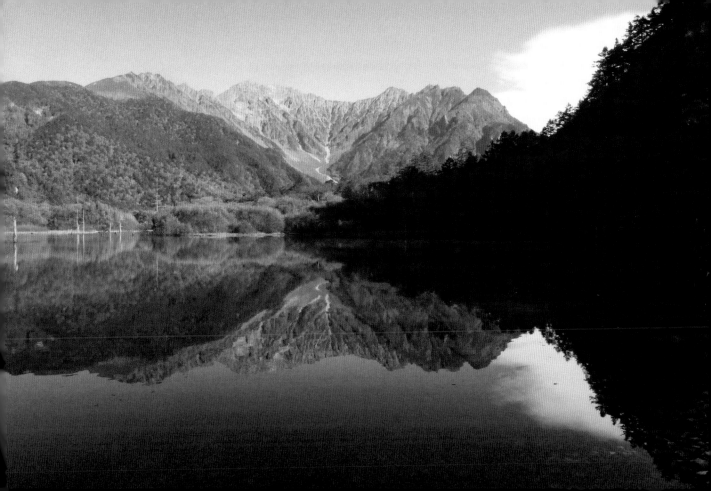

大多數受過傷的人，都迅速想要讓傷口癒合而強迫自己變得冷漠。
冷漠到最後，連自己的愛都感受不到，這才是生命裡最大的傷口。

Emotional detachment is a prevention strategy
Taken to isolate ourselves from future harm.
But little do we know
The eventual numbness that ensues
Cuts us off from the colors of life itself.

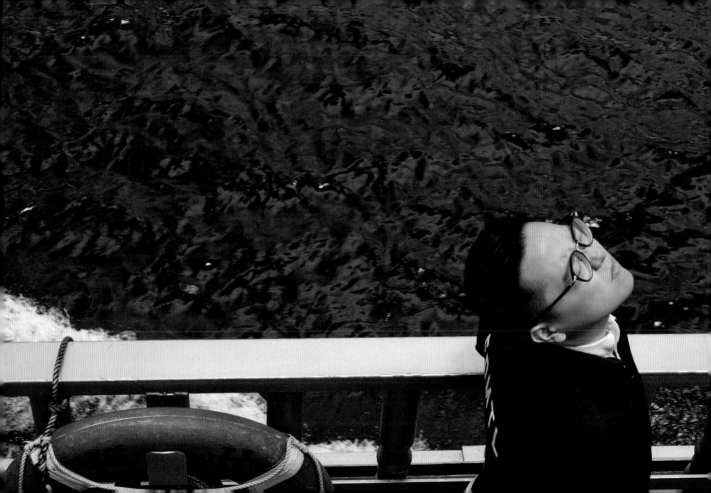

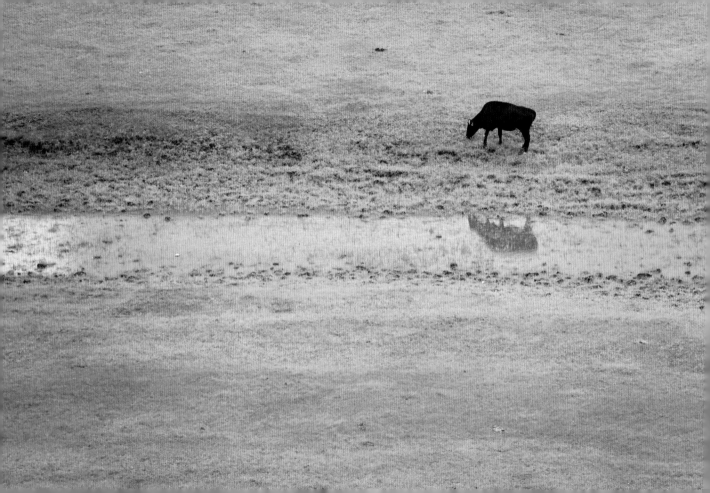

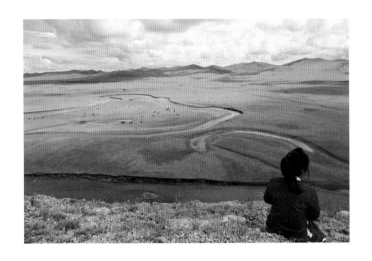

我們總在追逐夢中情人的典型，但卻也因此讓情感遍尋不著。
其實，「時間」會讓彼此成為心中最美的樣子，而不需要刻意的尋找，
那個根本不存在的完美。

Falling prey to the hopeless pursuit of The One
We find ourselves, lost forever in desolation.
Life is the greatest artisan, and Time, her carving knife.
Faith, is all we need to be her masterworks.

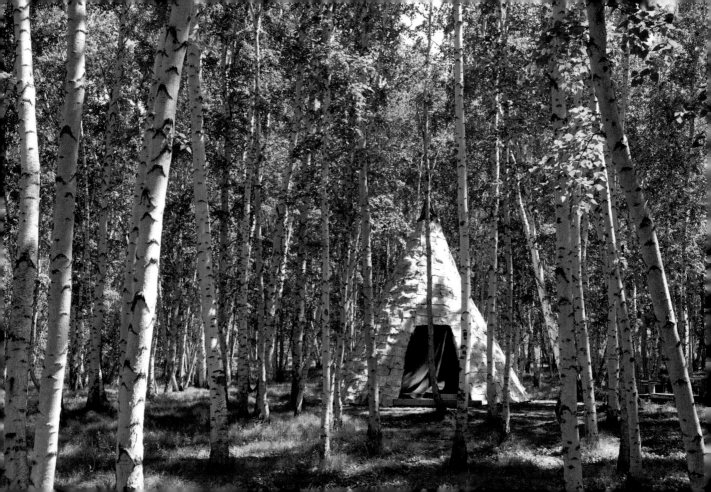

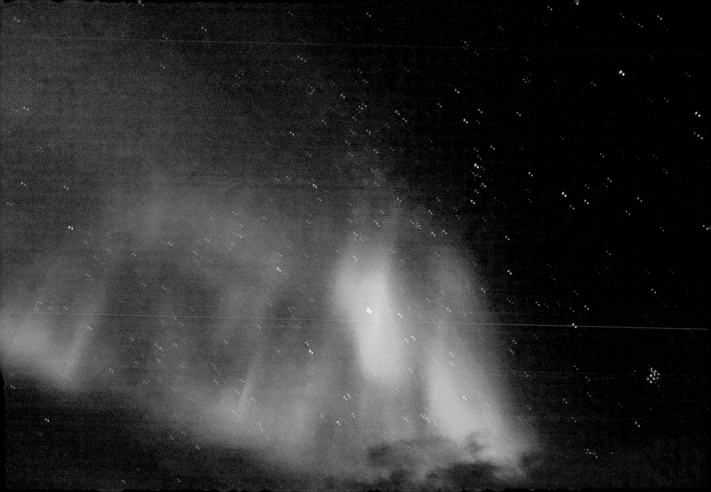

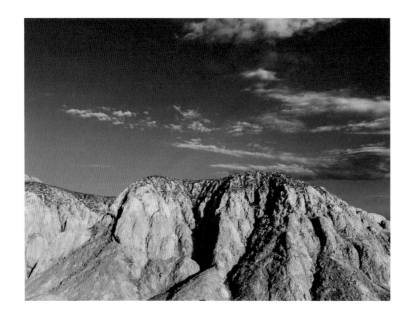

我們常因為少了愛，而感到孤獨。
但是，在孤獨時候找來的愛，通常都是讓你之後會更寂寞的「偽裝」。

We shiver in the loneliness of the night.
Yet finding a warm body is akin to
Drinking poison to quench the thirst.

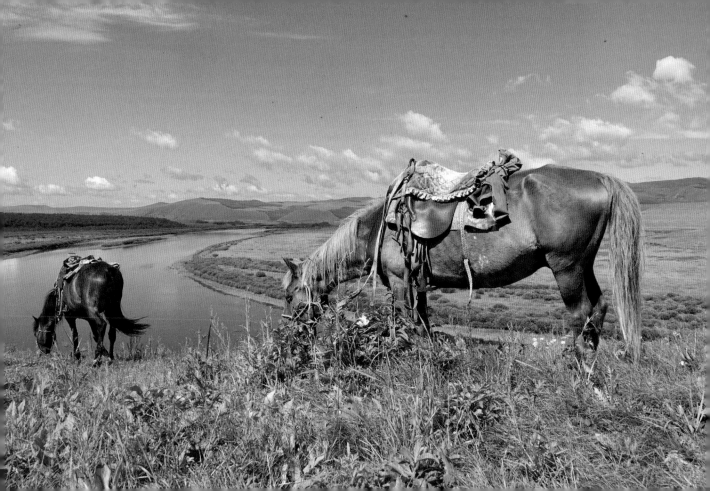

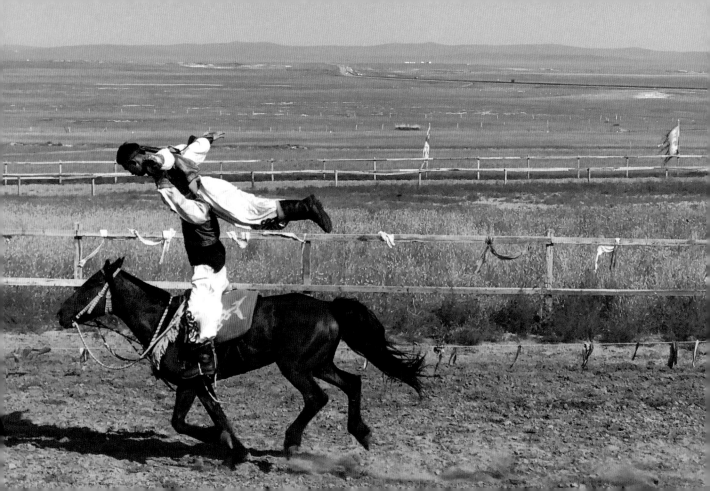

愛是要從平實的生活中，慢慢堆疊出彼此的了解和信任。
而不是一齣預寫好腳本的華麗演出。
只有懂得放下在愛情裡的掌控，才能在相處裡發現愛。

Love is founded on understanding and trust,
Not a pre-written best-screenplay-of-the-year.
Relinquish your need for control
And see love comes naturally to you.

不依賴的人生
Lead a Self-Sustaining Life

我們的不快樂，不是因為物質的匱乏，而是因為心的流離失所。
要讓心找到一個安定的家，才能相遇生命裡長久的喜悅。

Discontentedness
Comes not from physical deprivation
But a wayward heart.
Find your center, find a place of belonging,
And you shall find true happiness.

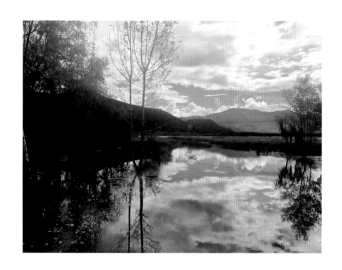

人一旦「有心」，難免會傷心。
而所有的傷終究只是人生的過程，人不該怕被傷心，只怕被歲
月磨成了「無心」。

As the heart feels, the heart aches.
But pain, being a spice of life, is not what one should fear -
As opposed to losing heart.

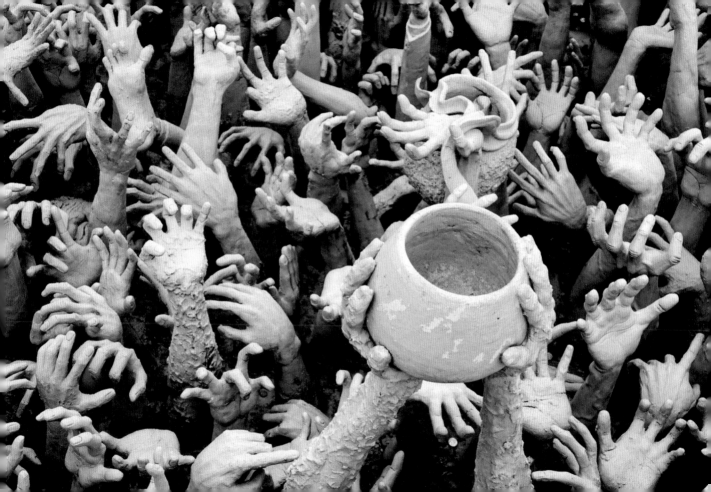

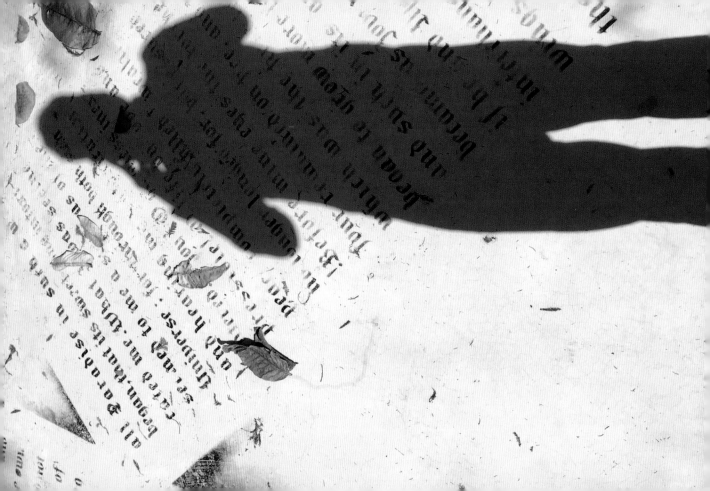

人生總有起落，能不能活得精采，不在於能爬多高，
而在於面對困境低潮時還能微笑。

Life is a rollercoaster ride.
The best moments are not always at the top,
But when you are still laughing at the bottom.

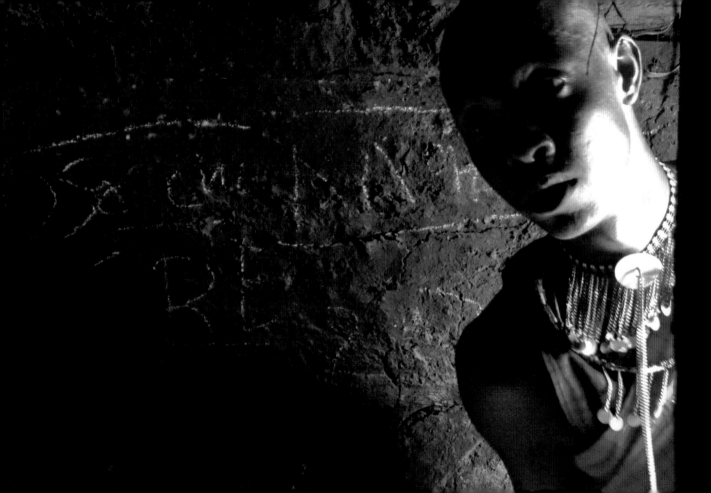

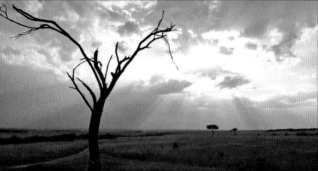

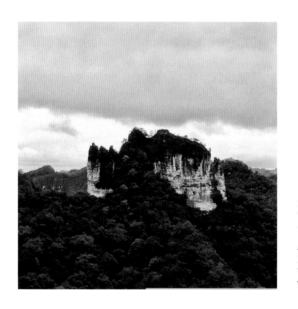

生命不是安排，而是「追求」來的。
當你願意用行動，超越別人對你的想像，
便能成就此生最美的巔峰。

A pre-arranged path cannot be called life.
Everything in life is earned and achieved.
When you exceed all expectations -
That's the true height of your life.

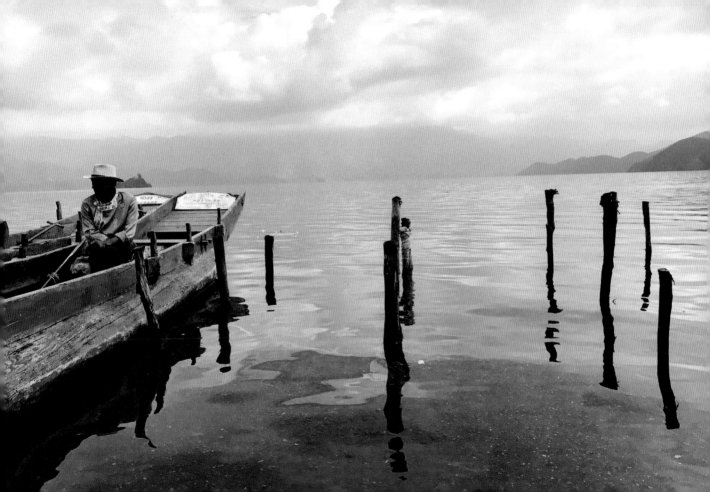

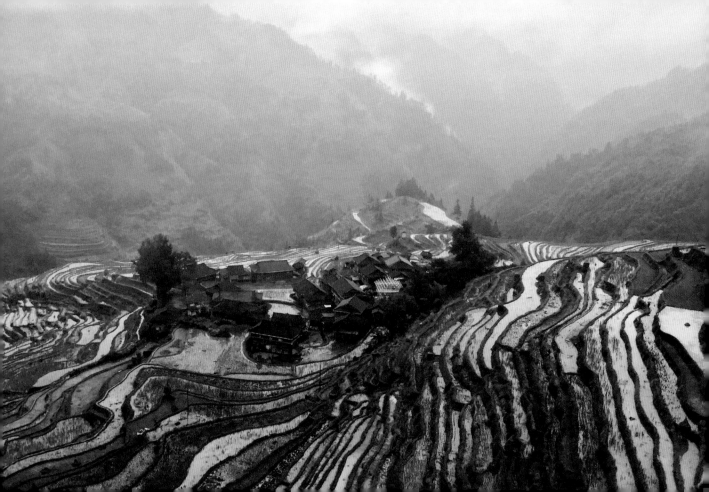

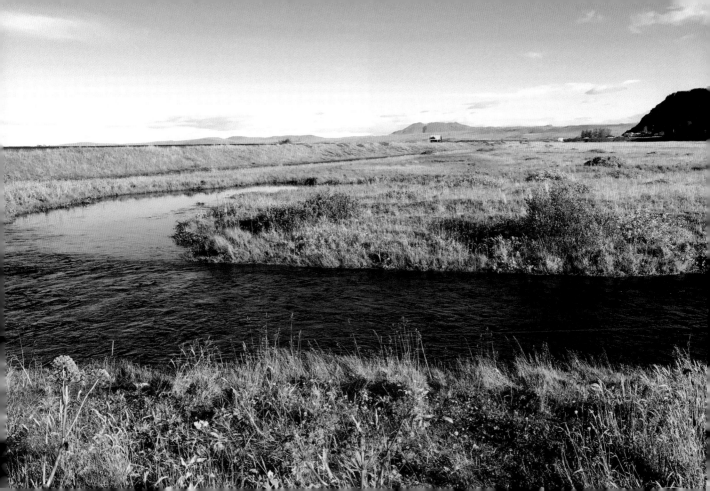

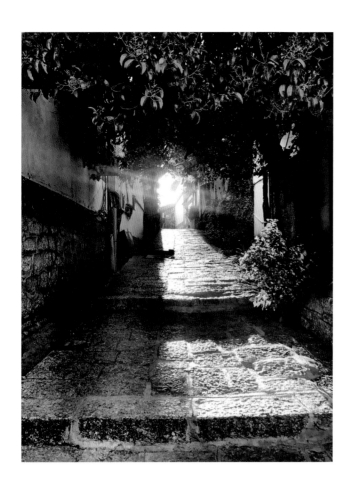

創傷，就像個癌症。
你越想要隱藏它，它就會在心裡陰暗處不斷的擴散；
只有在你願意讓它面對風雨，面對陽光，它才能被療癒。

Psychological trauma is like mold.
The more you try conceal it in darkness,
The faster it grows and spreads.
The only way to kill it is to
Bring it into the light.

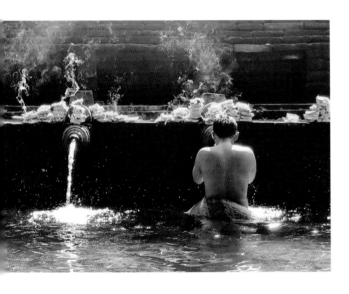

「做自己」不是要你不去在意別人的感受；
而是你對自己的信心，別被別人輕易的改變。

Being yourself isn't about being egocentric.
It's about your confidence being not easily shaken.

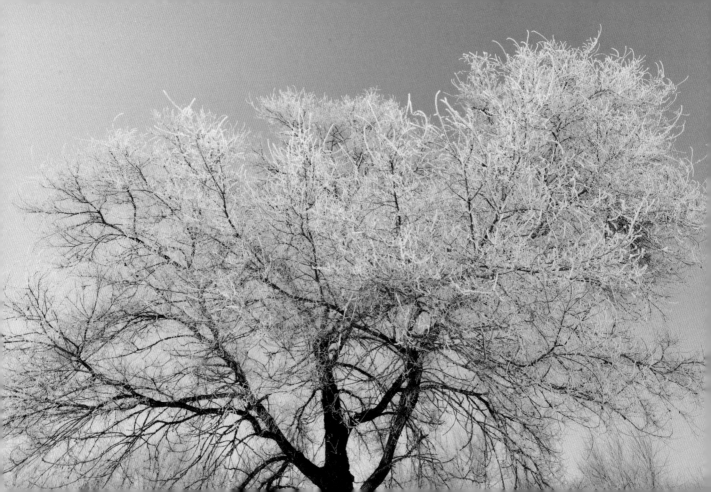

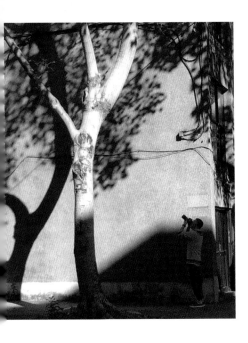

從來都沒有完美的人生，你得到了某部分的滿足，就會有另一部分的缺憾。
當你在羨慕別人的人生，是因為你只看到表面的擁有，而不知道他人生所失去的。

No one's life is without gripes.
There is always a price for everything gained.
So you envy only because
You see what others enjoy, not what they've sacrificed.

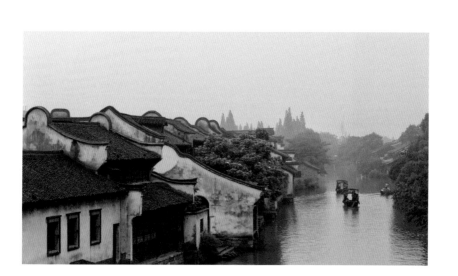

一個人的成長和歲月沒有絕對的關係。
而是在曾經迷失和挫折的痛苦經驗中，與人情冷暖的體會後，
你才會在人生裡，看見自己真正的成熟。

 Maturity does not necessarily correlate with age.
Only through perplexity, failure, pain, and the fickleness of human nature
Will you be able to look back and see personal growth.

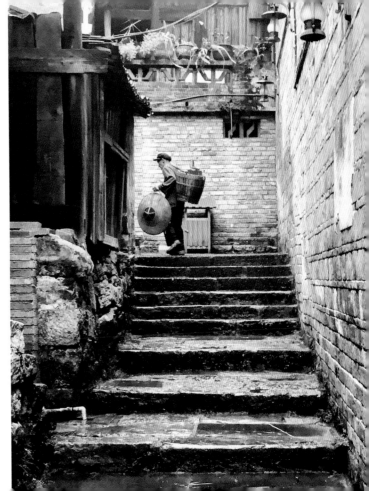

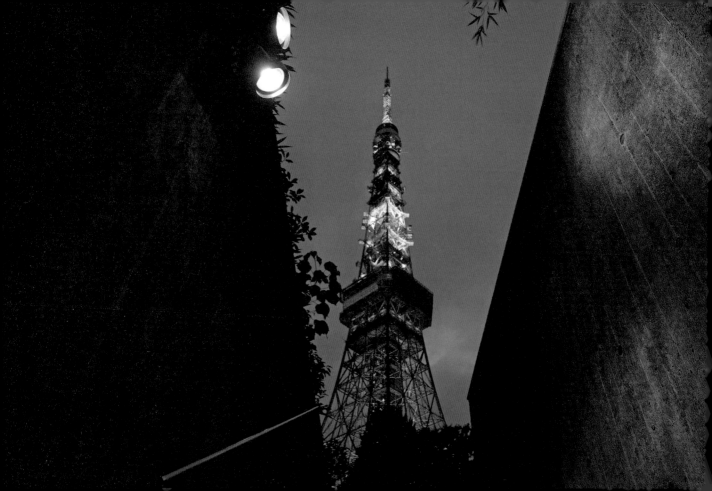

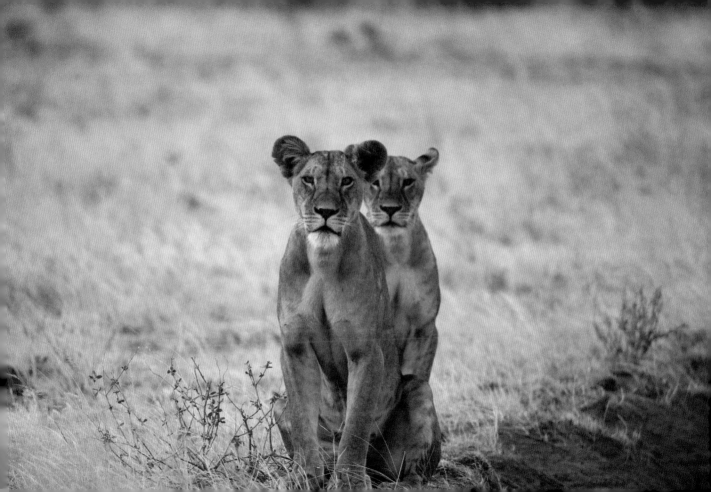

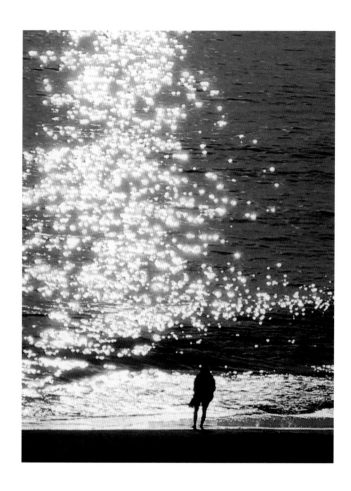

假如我們有向死而生的勇氣，
那麼再深闇的恐懼，也不過只是人生的過場。

When you truly learn the meaning of being-toward-death,
You'd be able to regard all fears with adamance,
For "this too shall pass."

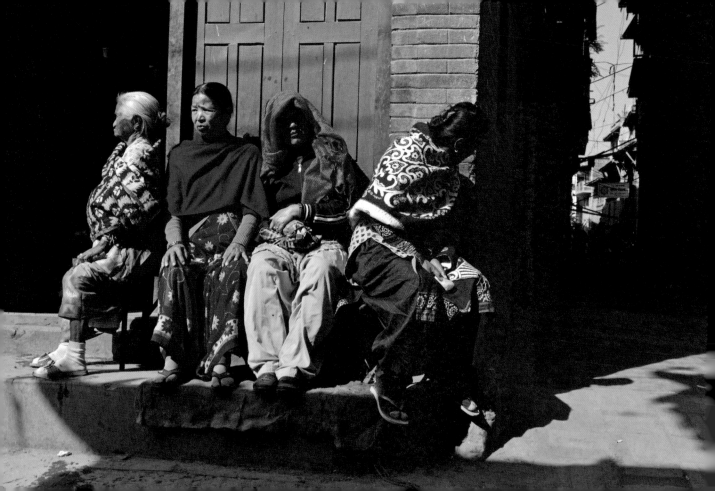

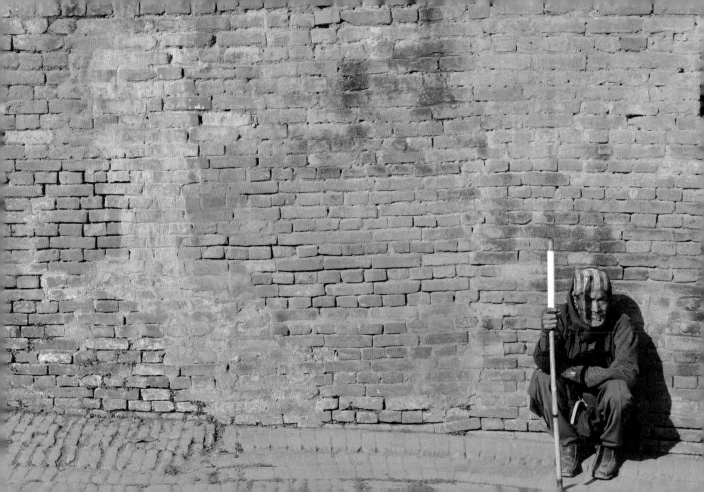

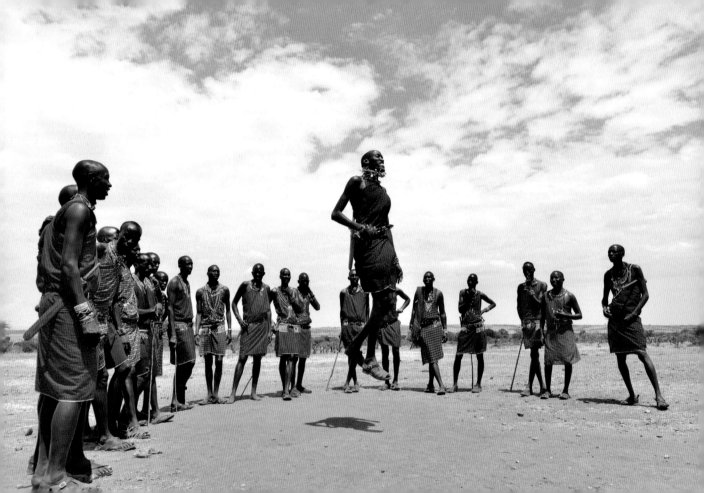

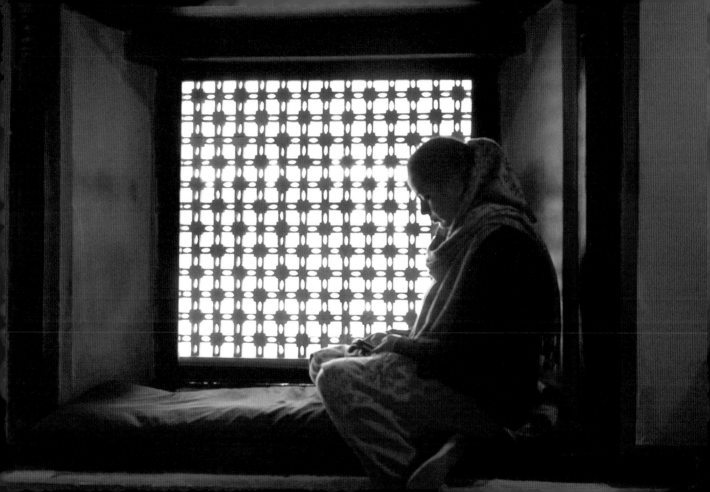

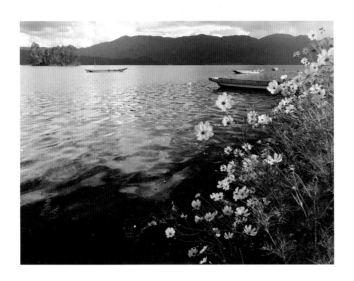

「痛苦」常常是因為得不到而來的！
因為你的慾望驅使了你有更多的比較，而成為心中隱隱的羨慕或者妒忌
其實，沒有誰註定有圓滿的人生，只是努力的道路不同而已。
能走到終點的，都是值得美麗的祝福。

Misery comes from not getting what we desired.
Desires beget comparisons beget jealousy.
But why envy a different path taken in life?
All are equally praise-worthy for the heights achieved.

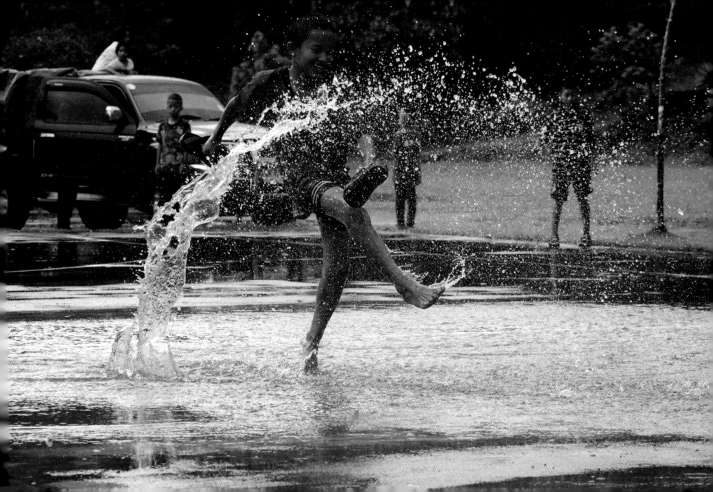

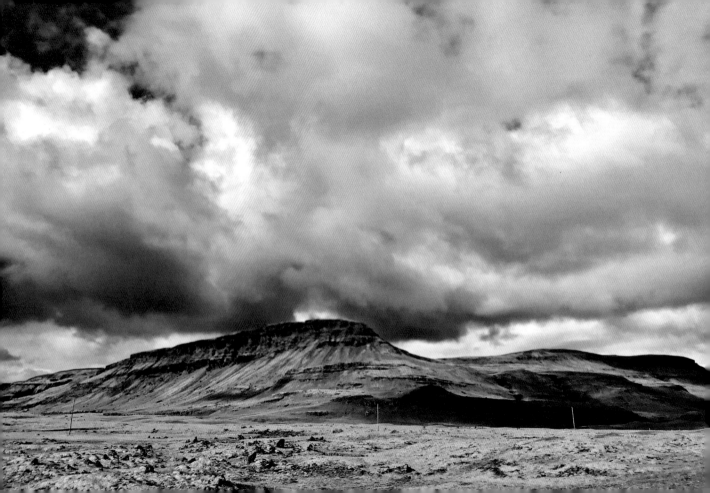

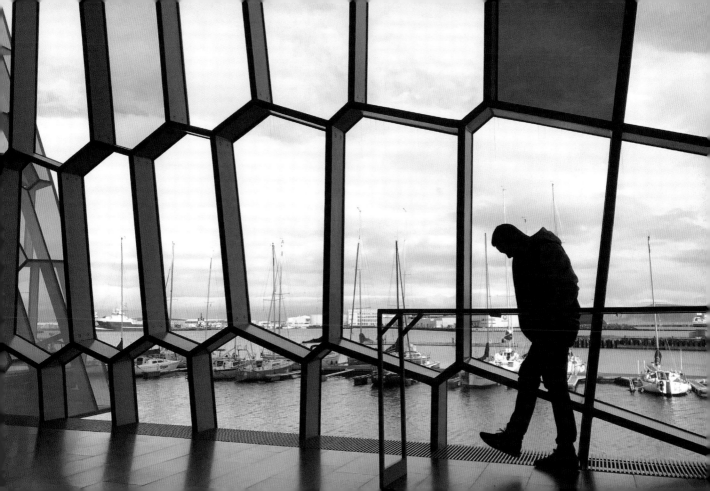

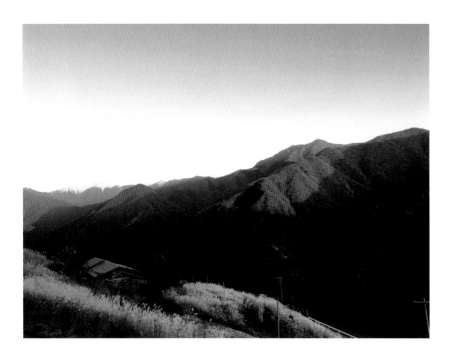

不要把自己人生的缺憾，寄託在別人的身上。
沒有人可以圓滿你的失去，只有你自己願意面對傷口
療癒完整的自己，才值得被愛！

Never blame others for what you're missing in life.
None can make up for what you've lost,
But you're deserving of being loved only if
You can look at and accept yourself in the mirror.

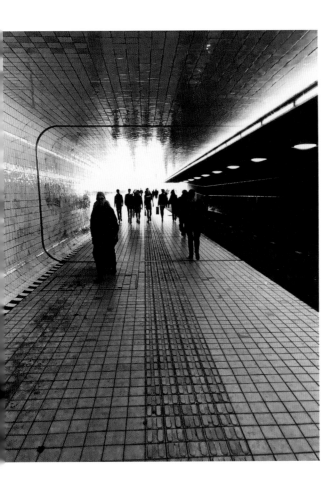

不要期待人生如你所願。
儘管很多時候，我們所努力的和結果都背道而馳，但這正是走向成就的累積。真正的失敗，是你將走過的路，視為無功而返的放棄。

Life is never a straight road.
Even fruitless hard work earns you positive experience,
Building you up toward your eventual success.
True failure is, and always has been,
Seeing no value in mishaps and submitting to defeat.

放別人的好在心上
Keep a Courteous Heart

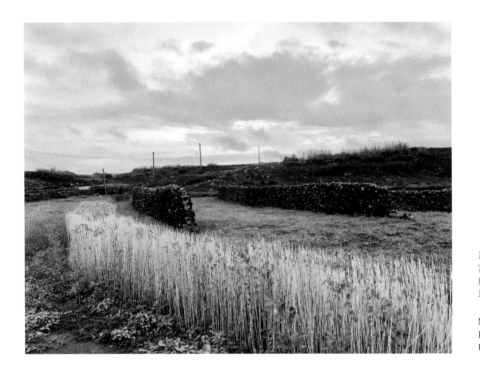

每一個人在他的生命裡，都會有他自己的難處。
當我們討厭一個人的時候，只要你願意把自己換
成是他的立場思考，那麼，你也許就能同情甚至
理解了！

None is without life complications.
Enter the spirit of the ones you despise.
Understanding is never gained without insight.

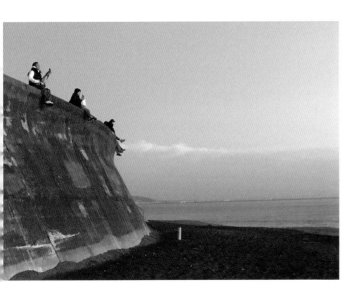

「成長」是不斷告別的旅程。
在生命裡來來去去的人，總是讓我們感慨人心的變化。
但時間和環境都在轉變，每個人也都有他自己處境和心境的移轉。
不用對失去的時光感到嘆息，因為就連我們自己也都會改變的。
曾經相識，有留下過美好的記憶，也就不枉費彼此的相處了。

Growth is a journey weaved of partings,
Each a lamento of the fickleness of human nature.
Yet change is the only constant in this world.
A lovely time spent is worth the memory in its own right.

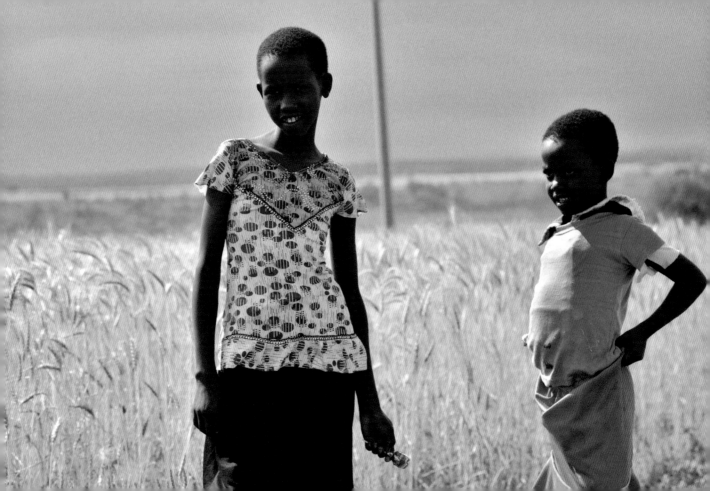

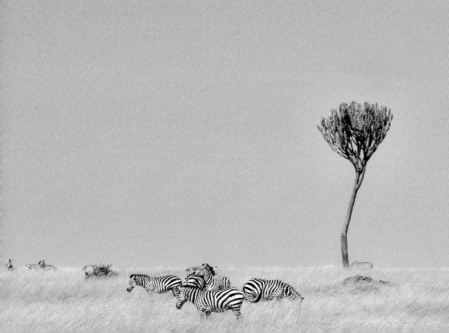

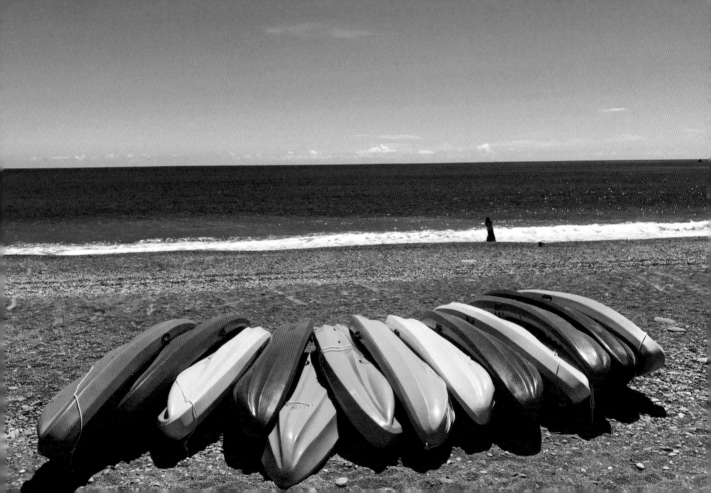

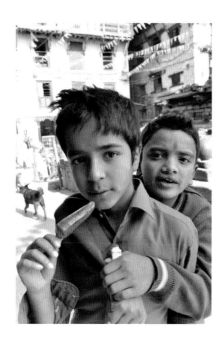

兩個不同生命經驗的人相處，不可能沒有摩擦的。
當有摩擦時，不要把「沉默」當成反正說了也沒用的理所當然。
因為沒有誠實的溝通，就像兩條平行線，不會有真正的「理解」。
沉默只會讓心裡的距離越來越遠。

Disputes are unavoidable between any two
Individuals with different life experiences.
Yet silence achieves lesser than failed communications.
Without butting heads, two lines shall
Forever remain parallel.
Shame, for all the empty spaces wasted in between.

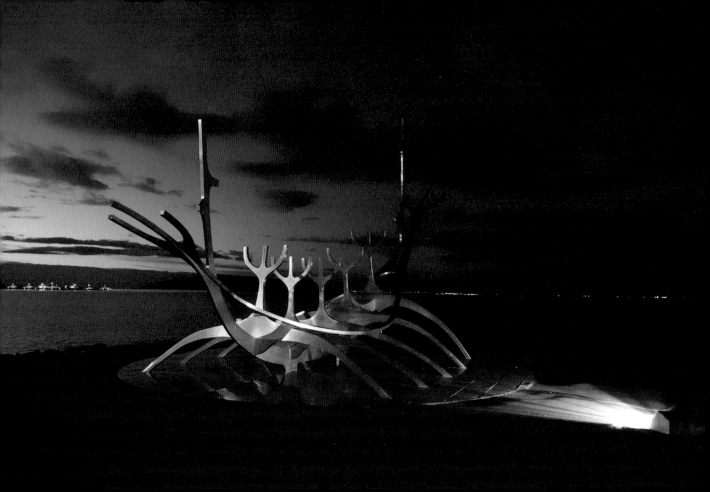

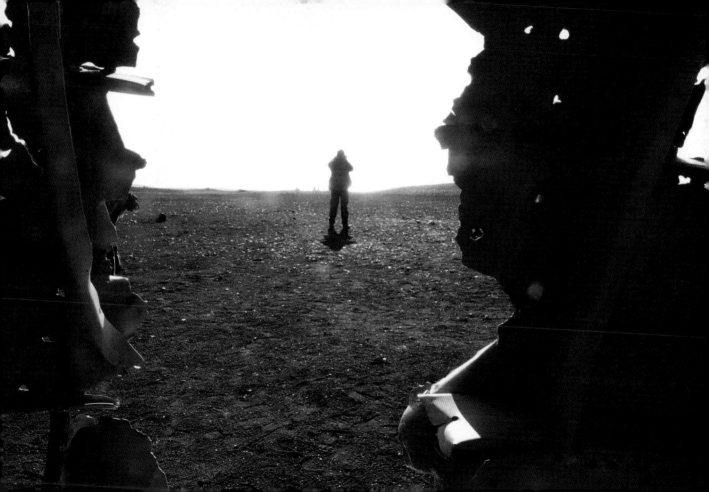

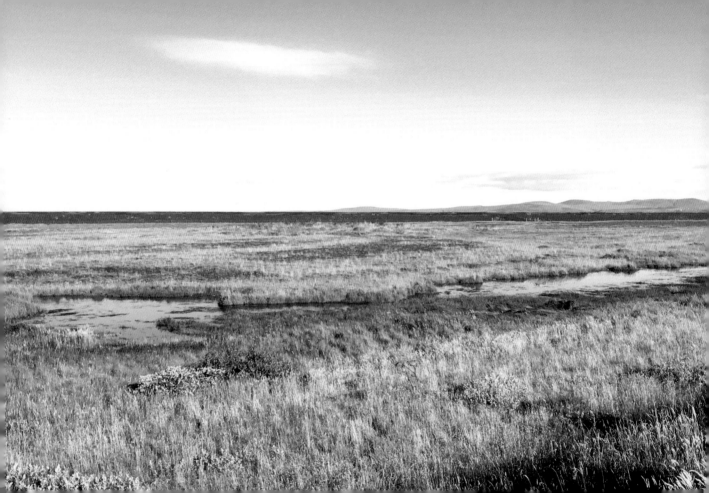

你必須努力站上世界的屋頂，才能看見世界的樣子；
你也必須讓出寬闊的心胸，才能裝得下自己和別人的不完美。

Climb unto the roof of the world to see the world.
Open your heart in humidity to make room for imperfections
Of your own before others'.

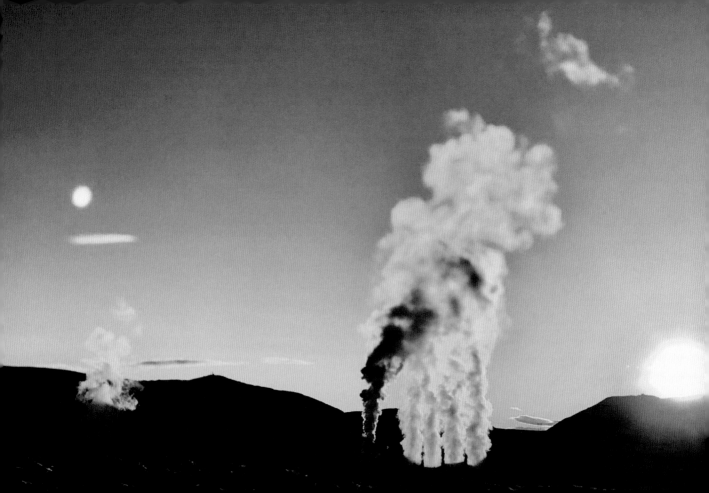

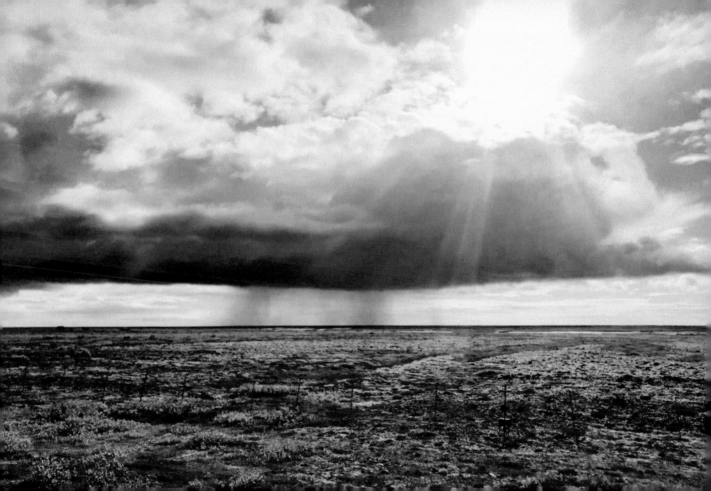

生命看似很長，卻也很無常！
在不能掌握長度的當下，不需要花太多時間，去求得別人的認同。
你只需要對自己的人生負責，真正的朋友是會懂你的。
不懂你的，解釋再多也不會有意義。

Life is a long journey, but not without unpredictable stops.
Why waste precious time begging for understanding from others when
Ones that understand, already do; ones that don't, never will.
Be the master of your own life.

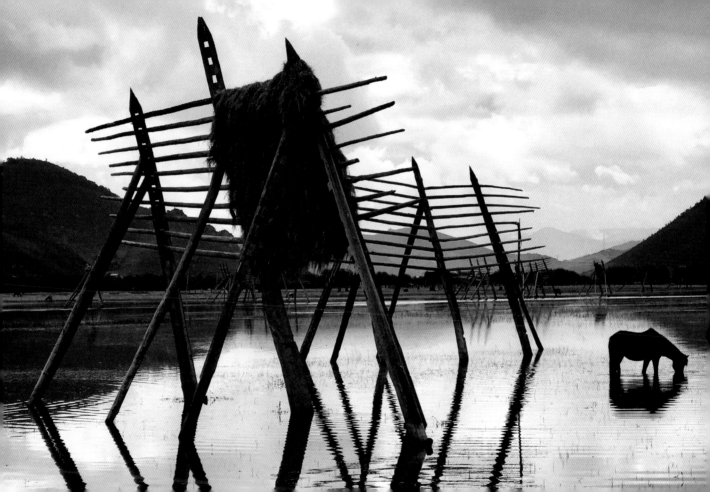

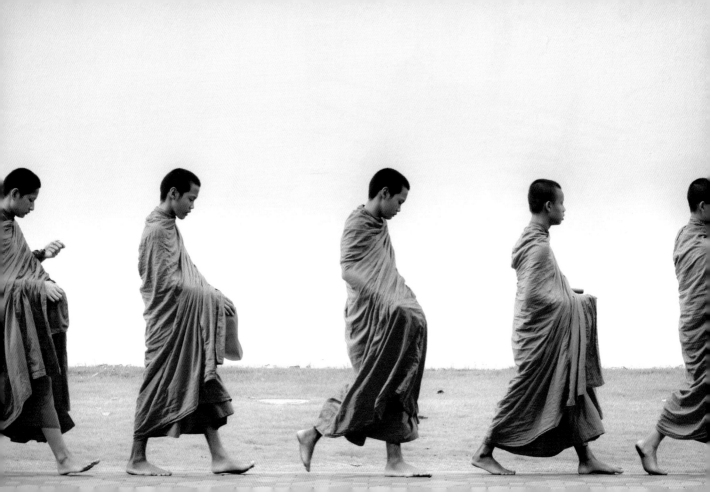

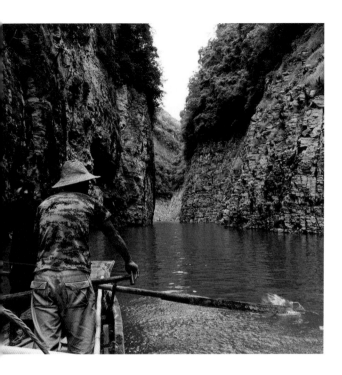

「偏見」通常還伴隨著無知，讓我們不是在真正了解一個人或一件事情之前，就下了結論，而這個自以為是的結論，就像阻隔視野的防護罩，只會窄化了我們的心胸，錯過許多值得珍惜的人事。

Prejudice is a product of ignorance:
A conclusion based on neither facts nor understanding.
It is a blind pulled over the eyes, a cage forced upon the mind
Insulating one from all the beautiful encounters in life.

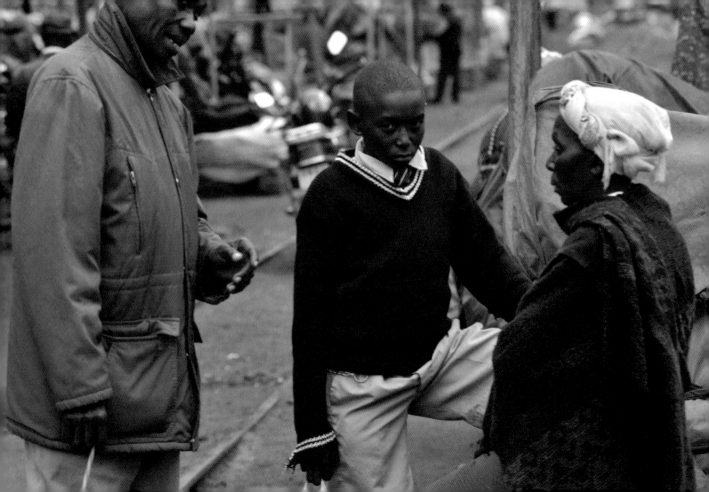

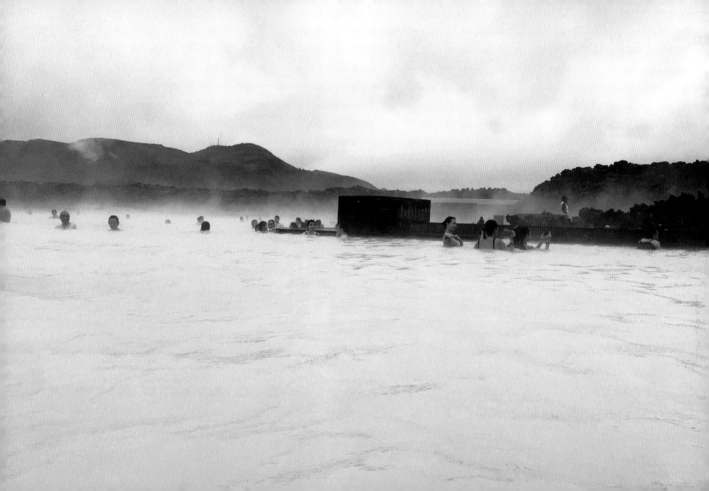

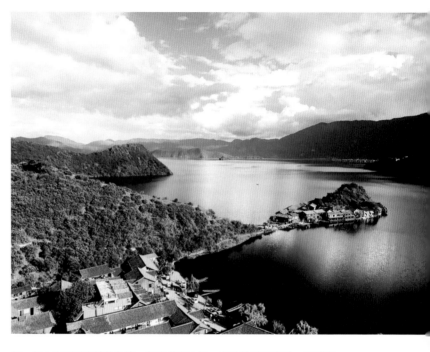

每一個人在不同事情的角度，都會各有立場，未必凡事都要爭一個輸贏。
你所留給對方的餘地，也將能種下彼此良善的因，結成日後你意想不到的果。

Views differ from one standpoint to the next.
None is necessarily right, or wrong.
Always leave others room to breathe,
For kindness always come around.

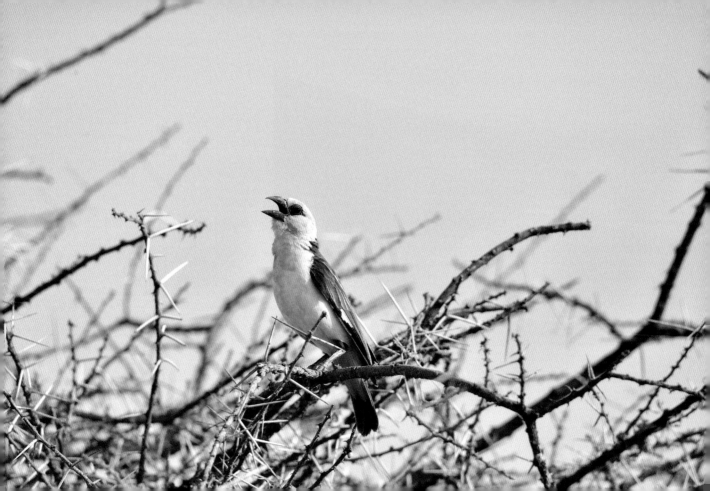

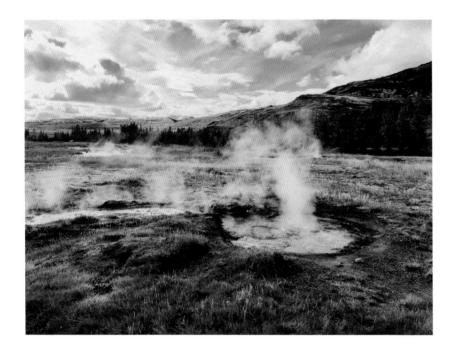

我們的恐懼，往往來自於你擴大了現實處境的困難，
造成心靈上的限制。其實，心的強大是可以被運用，
當成控制你未來命運的鑰匙。
只要你相信了，就能打開人生更大的門。

Fears are often illogical manifestations of a mind
Confined by a singular focus on the difficulties encountered.
The mind, however, can be a powerful tool when used right,
A key to unlocking new doors and taking control of your life
'Tis the power of believing.

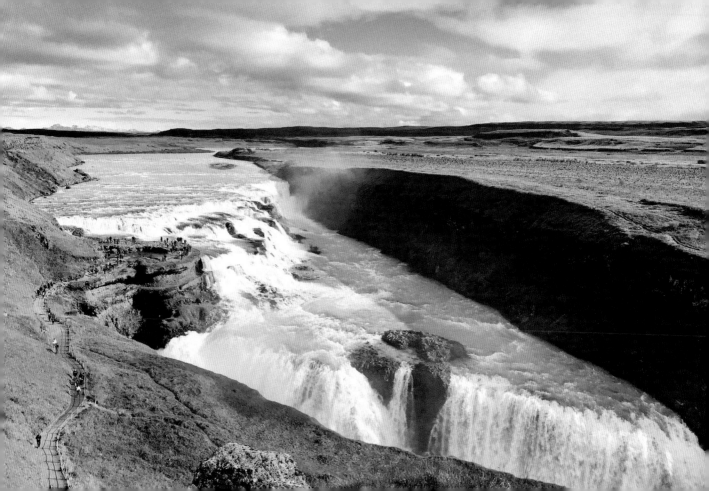

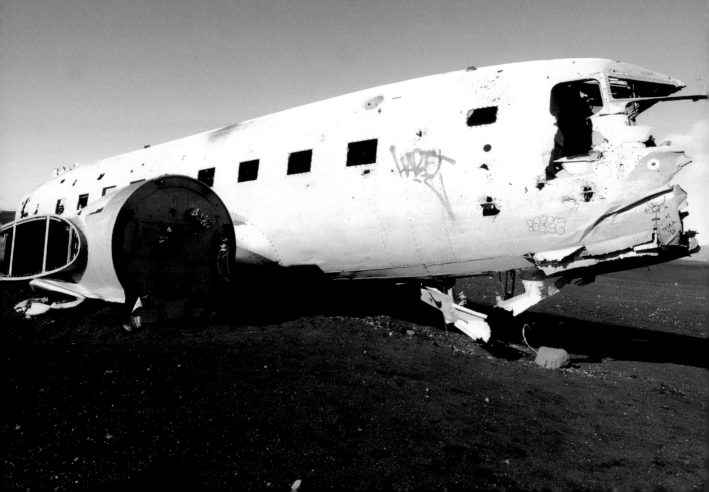

人生沒有永遠留得住的人與事。
既然什麼都留不住，那就更要好好珍惜現在擁有的。
有一天，讓離開的不是遺憾，而是好好的「再見」。

Nothing lasts or is yours forever.
All the more reason to seize the day
To transcend grief in the eventual parting.
A true fare-well.

堅持走一條對的路
Walk a Righteous Path

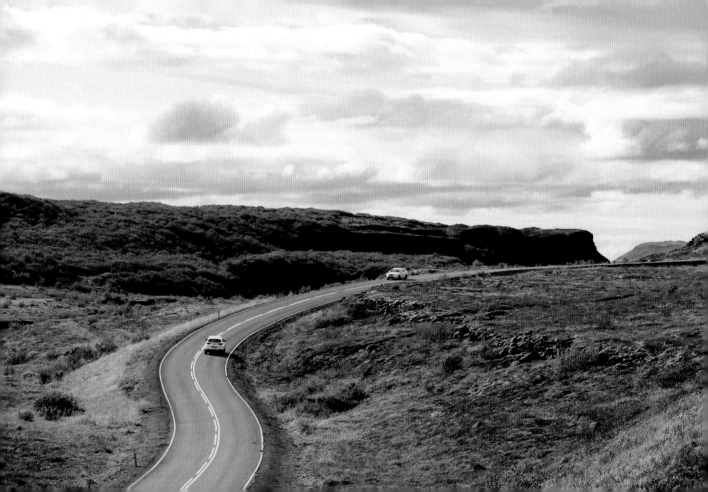

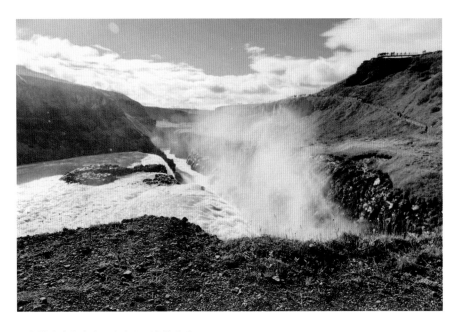

只有被放棄的生命，沒有過不去的人生。
在人生命運中，難免會遇到撞牆期。
但真正會令人絕望的，其實是因為你的放棄；只有在你願意以堅持換取時間，你的生命總會找到它自己的「出路」。

No challenges or obstacles are too great to overcome.
True desperation comes only from a defeated heart.
When willing to trade time for perseverance,
Life will always find a way.

我們常在兩人的關係中，尋找「燦爛」。
但真正的愛是歲月沉澱的結果，不是為燦爛而來。
而是能不辜負彼此，就已經是幸福了。

In a relationship, we often live only for its highlights.
But true love is a diamond that stood the test of time.
Blessed are those who fail each other not.

「年紀」不會讓你變得有智慧，
但「經歷」可以讓你成為有故事的人。

Time does not grant you wisdom.
But experience makes storytellers.

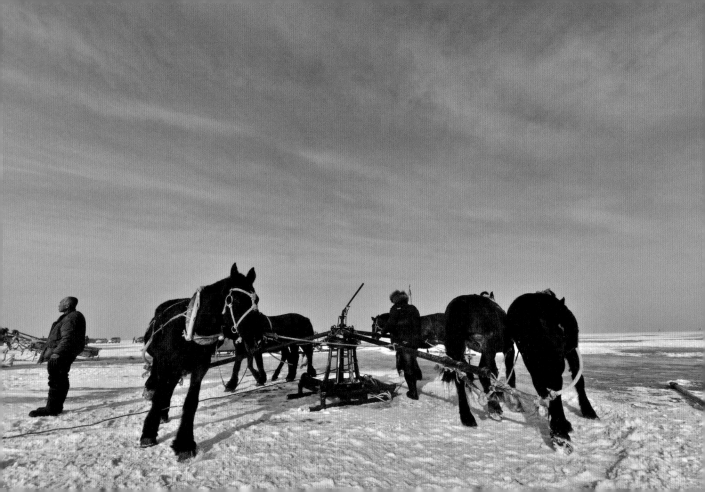

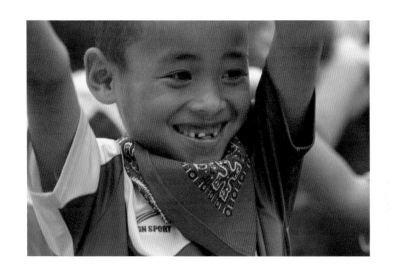

你不必去崇拜誰，也不需要去討厭誰。
只要能活出自己的模樣，就是對人生最好的交代。

Neither looking up to nor looking down upon someone
Makes for a more meaningful life.
Living your own life does.

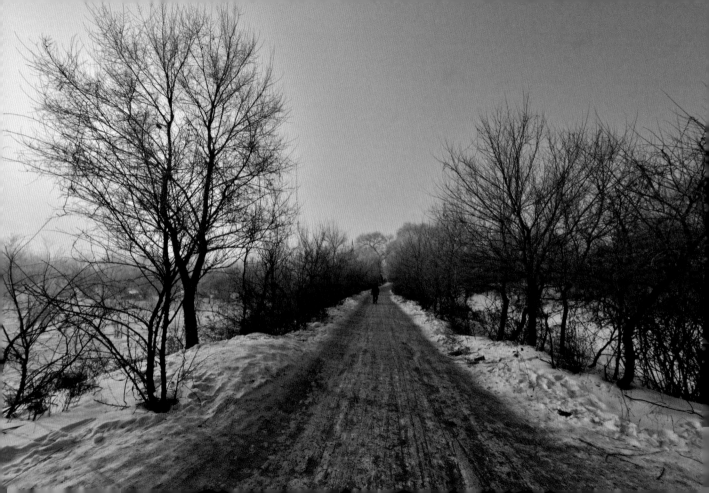

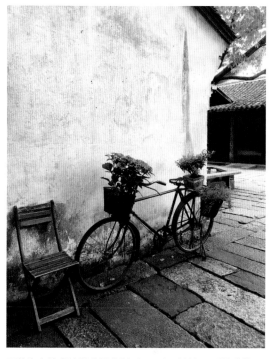

即使生命的處境對我們苛刻不已，也別辜負了這份苦難。
才能讓所有的經歷成為沃土，開出最美的花朵。

Take life's challenges as the biting cold
That fosters plum blossoms to bloom.

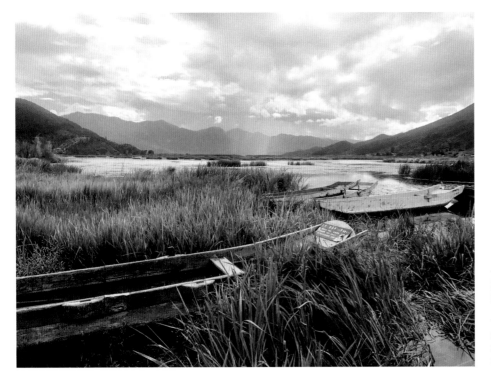

你不會因為迴避了苦難，苦難就不存在。
誰都想離苦得樂，但真正的安樂，是經由苦
難鋪成道路，才能抵達的彼岸。

Tribulations can be evaded -
For a moment only.
For true happiness is a Nirvana
Reached only by crossing the Vaitarna River.

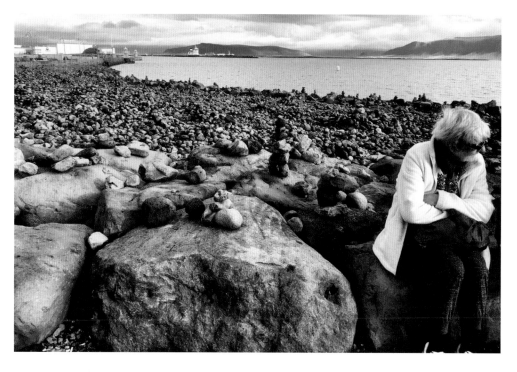

身處黑暗之中，是因為能將美麗看得更清楚。
而現在的困境，也只是來磨練我們面對未來更好的過程而已。

Light glows even more brightly in the darkness.
Life's morasses train our eyes
To behold the salvation waiting beyond.

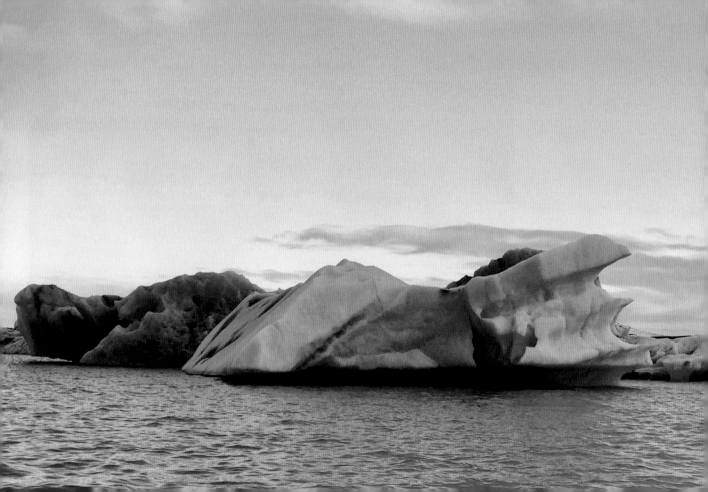

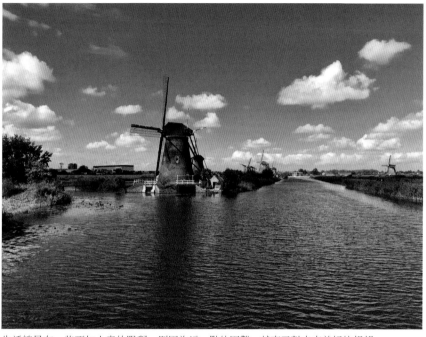

生活總是有一些不如人意的阻礙，別因為這一點的困難，就忘了對未來美好的想望。
很多時候，只要多堅持一下，就有不一樣的人生風景。
即使沿途沒有人為你鼓掌，也要走到自己滿意的終點，優雅的謝幕。

The stormy seas should not deter you from embarking on grand adventures.
The greatest splendors in life are sometimes right around the corner.
Even without applauds, you still own it to yourself
To see it all the way through to the end.

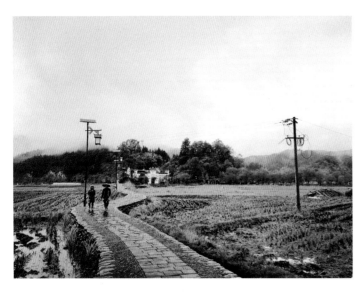

有時候，我們不滿意自己，只是因為跟別人「比較」的關係。
沒有一個人的人生是沒有缺憾的，你只是看到別人讓你羨慕的面向，在內
心形塑對方的完美罷了！
其實，我們都是在跟自己賽跑的人，哪怕今天只跑了一哩路，
你都已經超越了你的昨天。

Inferiority is comparative:
We feel inferior because we compare.
We often fabricate the perfect dossier for a person
Merely from the few aspects that we see and envy.
Know that we are only in a race with ourselves:
Every step forward is a step beyond our old self.

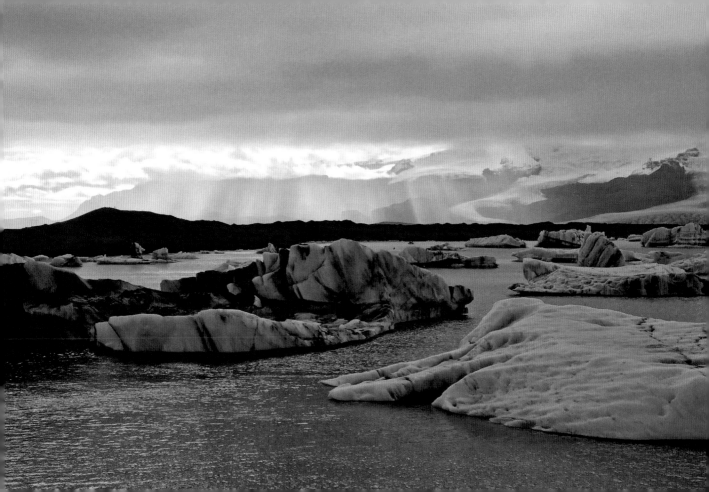

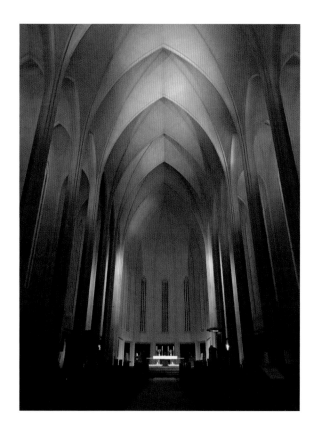

只要有不怕被打敗的信仰， 再怎麼痛苦的生命歷程，
也不能阻止我們通往喜悅道路的決心。

An unshaken faith
Is the straightest path to happiness,
Despite the miseries along the road.

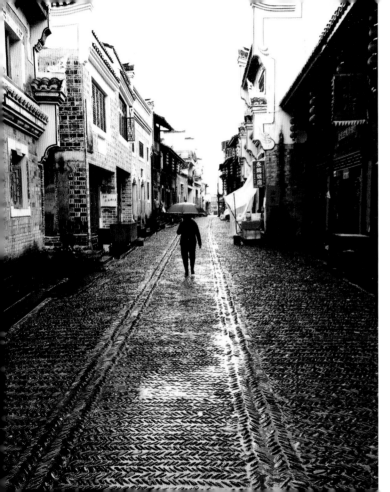

命運從來都是不公平的，從起跑點就開始了許多人之間的差異。
但是，人生也是一場漫長的競賽。
雖然有些人笑在開始，但堅持的人卻能贏在最後。

Fairness is never a fact of life.
Never do we start from the same starting line.
However, life is a long race.
Early bloomers do not always have
The last laugh.

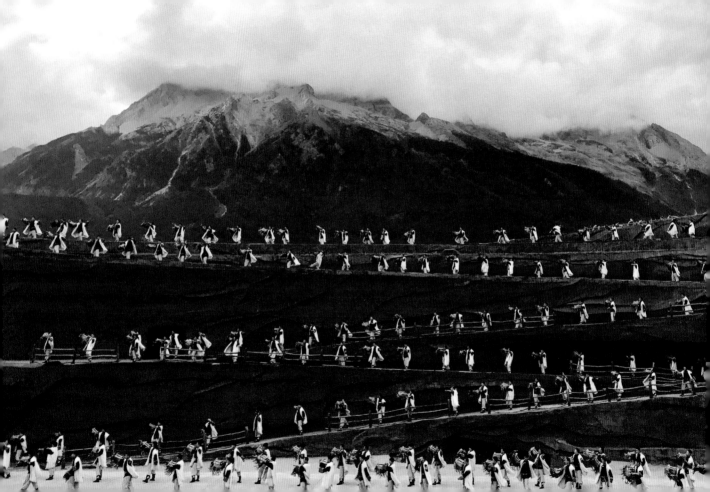

你不會因為沒有誰，就不完整；你也不會因為有了誰，才能完整。
當你看重了自己的價值，這世上的每一個人都是完整的。

No one truly in-or-completes anyone.
You're only complete when
You know your worth.

世界那麼大
Brave the World

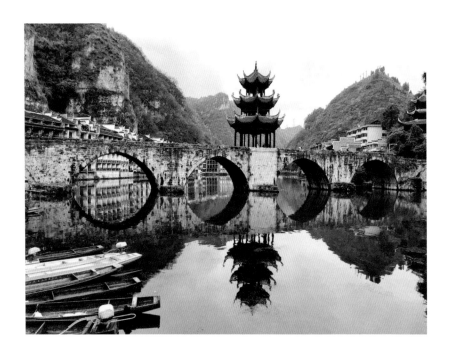

即使眼前是一片茫然大海，你也能造一座橋成為「風景」。
困難隨時都在，只是你有沒有信心，讓它成為機會。

A bridge over hostile waters is a sight to behold.
The successful turns difficulties into opportunities.

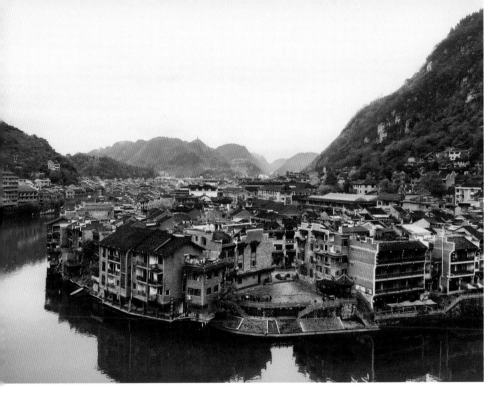

我們的痛苦，常來自對生活侷限的不滿。
當你願意去掉框架，所有的路途都會是心裡最自由的風景。

Our miseries often come from the boxes life puts us in.
Jump out of the box to take back your freedom in life.

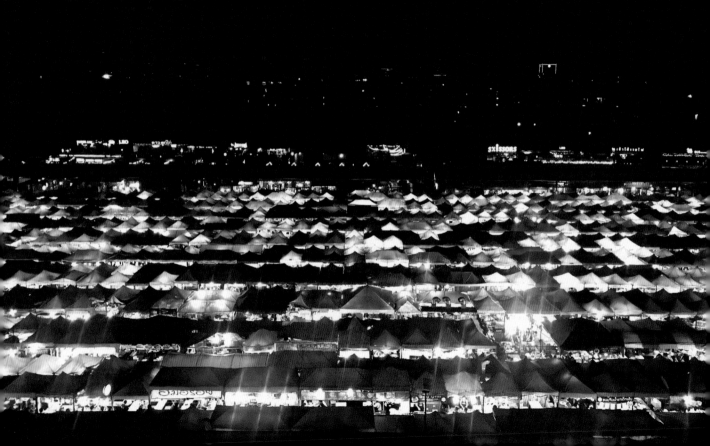

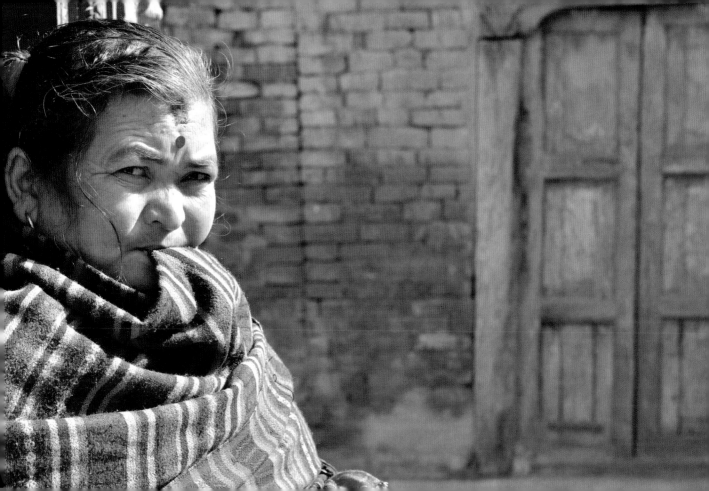

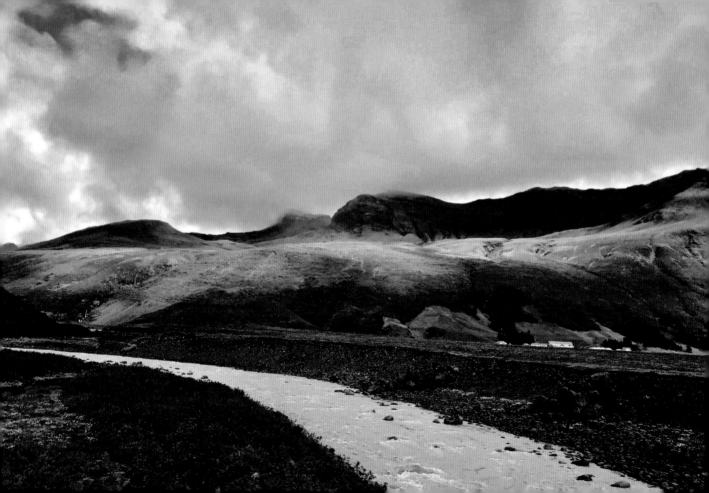

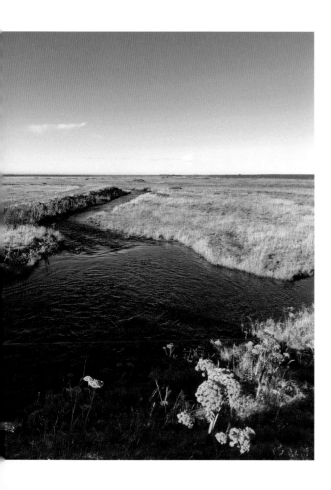

生活本身就是流動的，我們都在這流動的旅途去經驗，
所有好與壞都只是過程而已。能帶著不否定的自己往前走，
你的人生就是無可取代的。

Life is a flowing river; along we come for the ride.
Ups and downs are all part of the journey.
When you accept and cherish them,
Your life truly becomes your own.

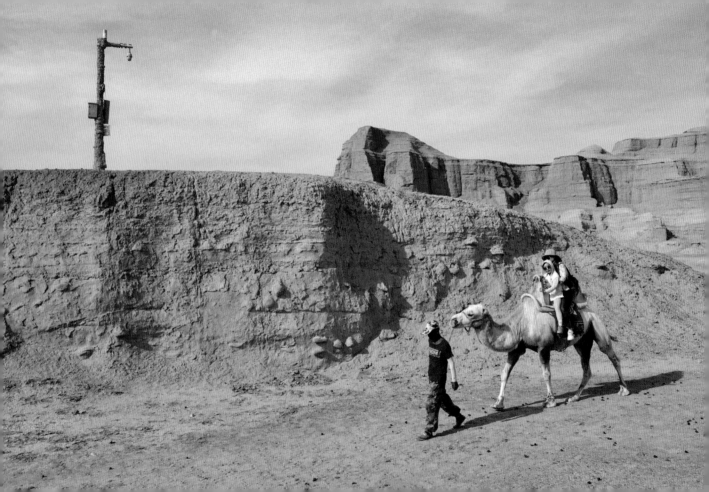

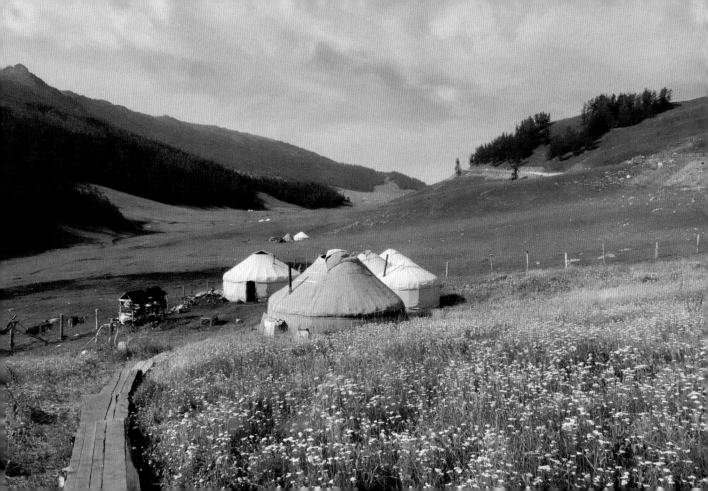

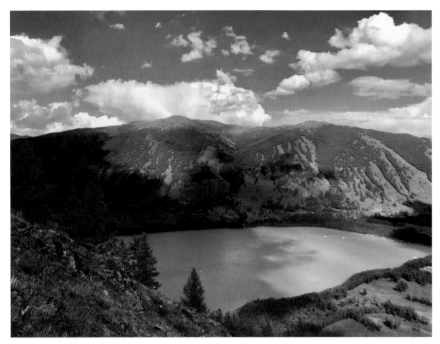

越在艱困的環境下，我們越要堅持走自己的路。
不管有多苦，都不要讓別人來決定你的人生。

Be persevering in your chosen path
No matter the challenge.
Never let another control your life
Under any circumstances.

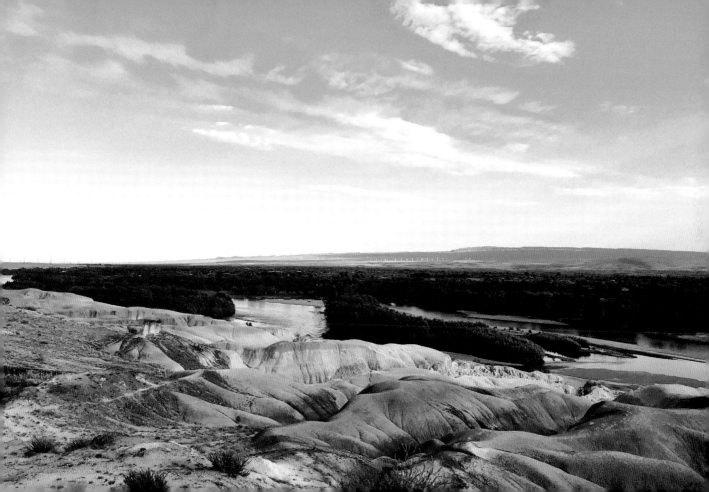

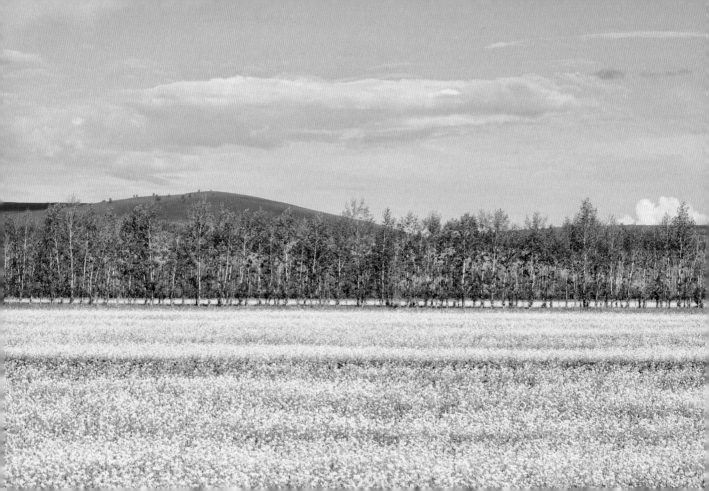

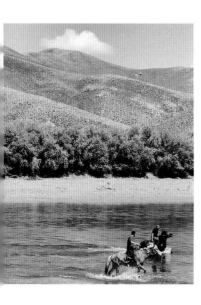

當我們走在一無所知的旅途，難免會迷茫前面的方向。
只有踏著相信自己的步伐，即使跌倒也不恐懼。

Getting lost is expected, braving the unknown.
Take prudent steps forward, but take them do -
Trips and falls shall then only be minor setbacks.

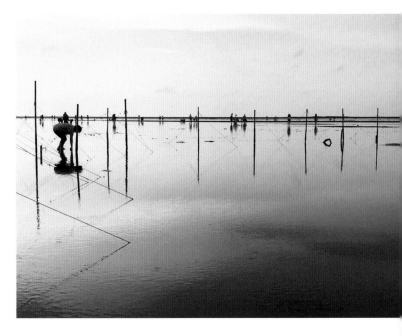

很多的人與事，隨著匆匆的往來，很快就被遺忘。
在越快速的時間裡，我們越要慢下腳步，才能讓
值得記憶的情感，成為生命中的美好。

Too quickly gone with the wind, things often are.
Slow your steps, take a moment,
And to take them in -
To your heart where they deserve.

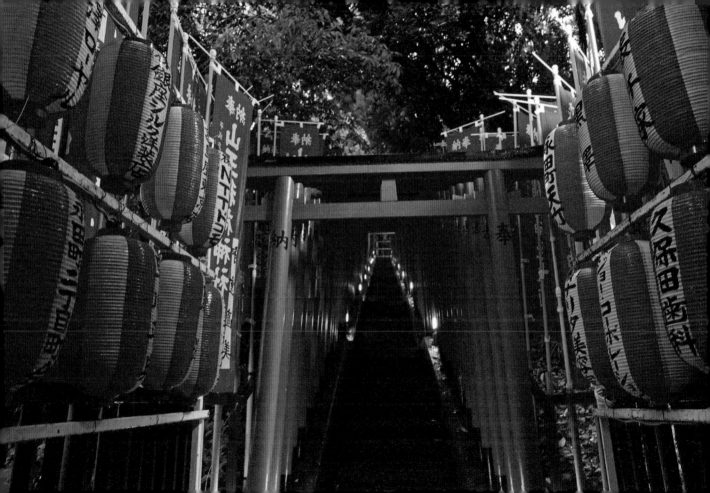

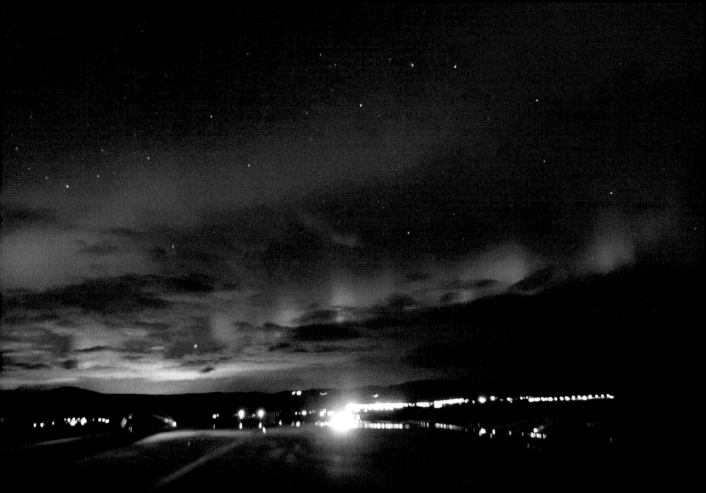

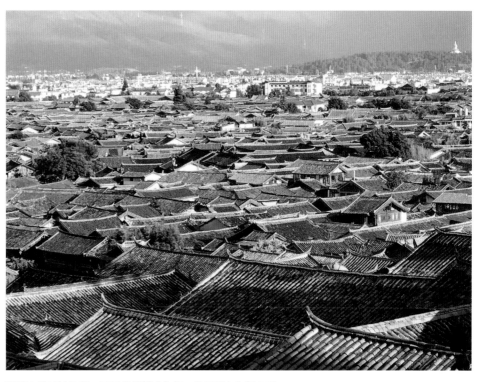

即使在陰暗的角落，只要我們願意仰望，世界就有無限寬廣。

Look up.
See the big world beyond.
See pass your predicaments.

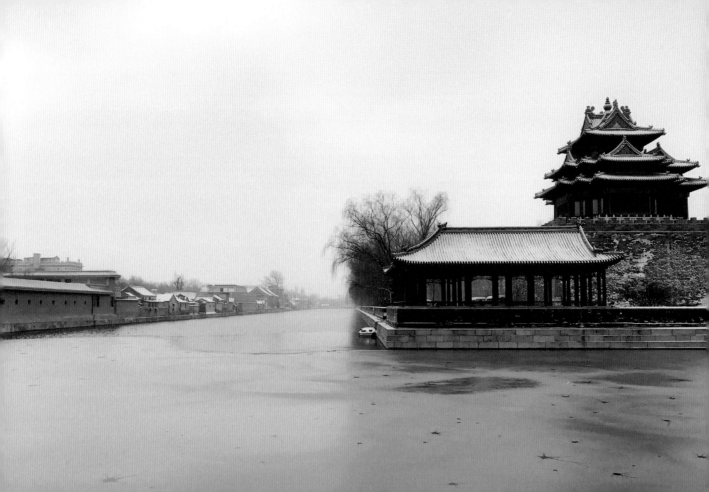

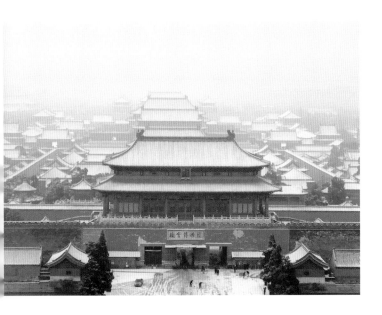

世界本來就不完美，人生也是苦的。
而我們來到這世界，就注定了要經歷這些苦，
才會懂得什麼是「離苦得樂」。

悲傷總是會終結的，就算世界暫時的失色，也要換個角
度欣賞雪白覆蓋的美感。
因為明天還是要繼續的，你用什麼角度面對，就決定了
你的心情。

We live in an imperfect world interlaced with pain.
Yet placed here are we, precisely, to experience,
And see pass the pain to learn true happiness.

Though snow bleached and buried the world,
Winter comes, so it shall go.
As do despair and melancholy.
Your own mindset makes or breaks your day -
And the days to come.

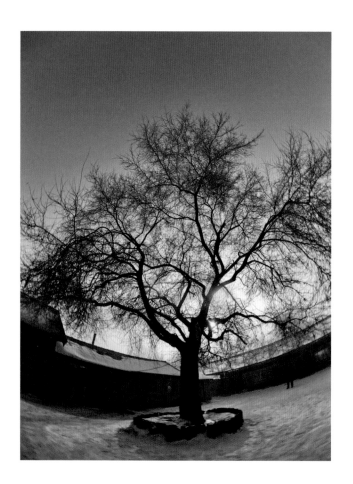

當你對自己走的路能深信不移，再怎麼崎嶇與荒涼，
也都能走出一片繁華風景。

When confident of your own stand and path
A rewarding sight surely awaits
Beyond the perilous hike and barren grounds.

豐和日麗攝影詩集．3，告白的力量 ／田定豐
文字．攝影． -- 初版． -- 臺北市：時報文化，
2019.01；184 面；20.1X13 公分
ISBN 978-957-13-7647-9（ 精裝 ）
1. 攝影集
975.9　　　　　　　　　　　　　　107021616
ISBN 978-957-13-7647-9
Printed in Taiwan

Origin 014

豐和日麗攝影詩集 3：告白的力量

作者、攝影　田定豐 ｜ 內文中譯英　羽蕭 Zephon W.- 統一數位翻譯股份有限公司 ｜ 主編、責任企劃　余玟鈴 ｜ 企劃協力　豐文創 Fun Art Asia ｜ 專案執行　楊化文、尹禎 ｜ 美術設計　陳康楚 ｜ 排版　陳康楚 ｜ 編輯顧問　李采洪 ｜ 發行人　趙政岷 ｜ 出版者　時報文化出版企業股份有限公司　10803 台北市和平西路三段 240 號 3 樓　發行專線 -(02)2306-6842　讀者服務專線 -0800-231-705、(02)2304-7103　讀者服務傳真 -(02)2304-6858　郵撥 -19344724 時報文化出版公司　信箱 - 台北郵政 79~99 信箱　時報悅讀網—http://www.readingtimes.com.tw　時報出版愛讀者粉絲團 -http://www.facebook.com/readingtimes.2 ｜ 法律顧問　理律法律事務所　陳長文律師、李念祖律師 ｜ 印刷　詠豐印刷有限公司 ｜ 初版一刷　2019 年 1 月 25 日 ｜ 定價　新台幣 550 元 ｜ 版權所有　翻印必究（缺頁或破損的書，請寄回更換）